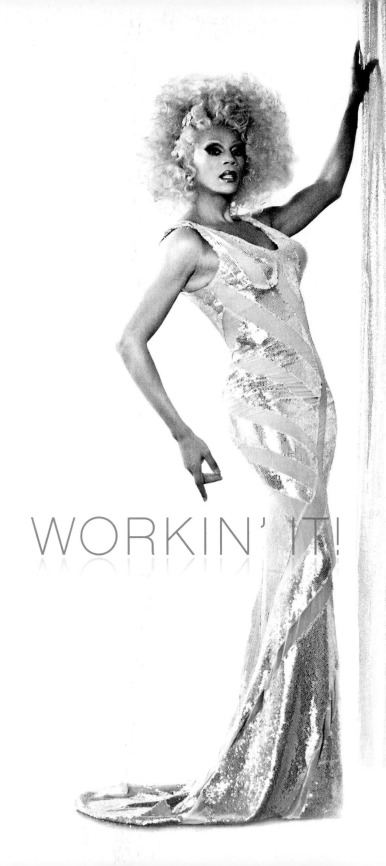

WORKIN' IT!

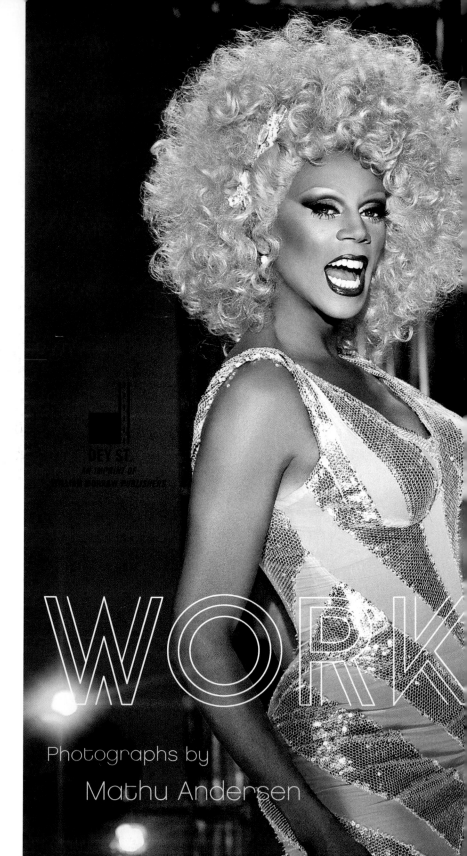

DEY ST.
AN IMPRINT OF
WILLIAM MORROW PUBLISHERS

WORK

Photographs by

Mathu Andersen

RUPAUL'S
Guide to Life, Liberty, and the Pursuit of
Style

IN' IT!

RuPaul

DEY ST.
AN IMPRINT OF
WILLIAM MORROW *PUBLISHERS*

All photographs by Mathu Andersen.

Designed by Janet M. Evans

Library of Congress Cataloging-in-Publication Data

RuPaul, 1960–
 Workin' it! : RuPaul's guide to life, liberty, and the pursuit of style / RuPaul.—1st ed.
 p. cm.
 ISBN 978-0-06-198583-6
 1. Beauty, Personal. 2. Fashion. 3. RuPaul, 1960–
 I. Title.

RA778. R93 2010
646.7´042—dc22

2009042495

16 17 CG/RRDC 11 10 9 8 7

CONTENTS

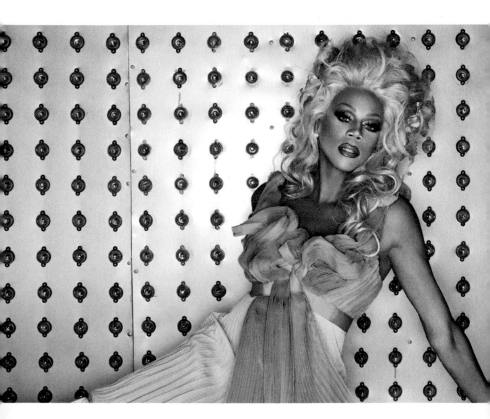

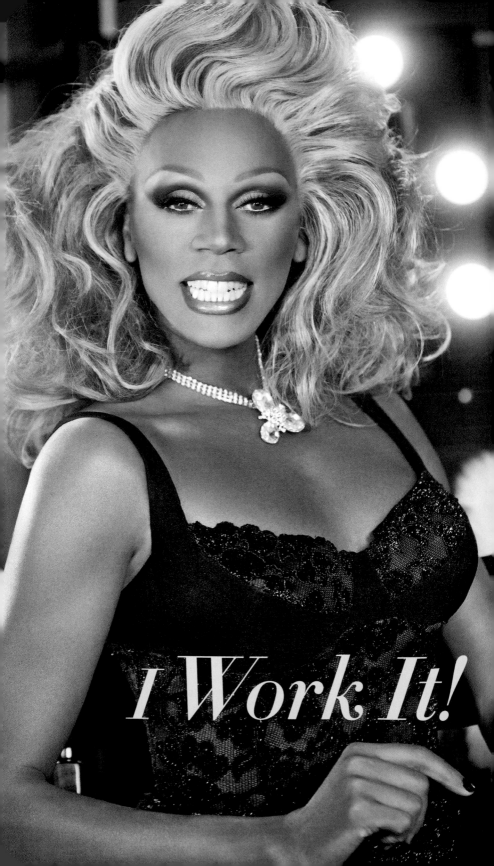

INTRODUCTION

INTRODUCTION

The best advice I've ever gotten was from my tenth-grade drama teacher, Mr. Pannell. At the time, I was going through a teenage drama of my own. My bad grades had finally caught up with me and I was being faced with expulsion from the only school I had ever really enjoyed going to. My teacher, seeing how shaken up I was, calmly pulled me to the side and said with an even tone, "The most important thing to remember, RuPaul, is to not take life too seriously." Excuse me? I thought. I'm about to get kicked out of the only school I've ever loved and your advice for me is "don't take life too seriously"? Are you for real? Of course, the truth and wisdom of his advice was lost on me then, but I never forgot it. In fact, over the next thirty years, it would become the creed I live my life by.

"Don't take life too seriously" has served me well in the way I dress (in and out of drag), in the

way I live, and undeniably in the way I *work it*! This easy-breezy approach is especially valuable when it comes to the people who want to suck me into their drama, misery, and despair. Honey, life is shorter than you think. I don't have the time to be mired down in the mud. I've sung that song before, and it ain't pretty. I choose joy. I'm a Scorpio, so I have a certain proclivity toward introspection, which isn't terrible. It just means I have to actively nurture my lightness so I can have a balanced experience. Is the glass half full or half empty? Both choices are correct, but one choice will bring you joy, and the other will bring you pain. Yep, I choose joy.

Balance is a key theme in my life. Being able to take a step back and recognize what the situation calls for is essential. Sometimes that ability is intuitive, sometimes it's learned, and sometimes it's having the clarity of mind to ask someone who knows.

As a child, I assumed everyone had been given an instruction manual except for me. I grew up in a house with all girls, so I felt like the little boy who fell to Earth. I was a sweet, odd-looking kid with a face full of freckles. I got teased a lot for being a sissy, and I most definitely didn't fit in. Being an outsider motivated me to study human behavior. My thinking was that if I could learn the rules of the game, then perhaps I could find a loophole and angle my way in. Well, I found plenty of loopholes, contradictions, and flat-out lies. And, honey, if I'm lying, I'm flying. Through my observations, it became clear that most of society's rules and customs are rooted in fear and superstition! That makes them beyond refute.

Yep,
I choose
joy

With that knowledge came a death and a rebirth: the death of my desire to fit in, and the birth of my acceptance of a life outside the box. There is freedom outside the box. There is truth outside the box. And it was outside the box that I began to truly understand and develop my own sense of style.

The truth is you are a spiritual being having a human experience. The human part of the experience is temporary. Think of it as a T-shirt and a pair of jeans. Your spiritual being is *not* temporary. It is eternal. Think of it as the sun and the moon. That's why the saying "You're born naked and the rest is drag" couldn't be more true. Drag isn't just a man wearing false eyelashes and a pussycat wig. Drag isn't just a woman with a pair of glued-on sideburns and an Elvis jumpsuit. Drag is everything. I don't differentiate drag from dressing up or dressing down. Whatever you put on after you get out of the shower is your drag. Be it a three-piece suit or a Chanel suit, a McDonald's uniform or a police uniform. The truth of who you really are is not defined by your clothes.

Okay, now I'm gonna really blow your mind. Let's take it a step further. Whatever you proclaim as your identity here in the material realm is also your drag. You are not your religion. You are not your skin color. You are not your gender, your politics, your career, or

your marital status. You are none of the superficial things that this world deems important. The real you is the energy force that created the entire universe!

There, I *said it*! I've spilled the beans on what your ego doesn't want you to hear: *you* are The Source, The One, The Big Enchilada (with an ever so temporary case of self-induced amnesia). But hey, we cool . . . we don't have to get into that right now. . . . Just know that when you're ready to accept it, everything becomes so easy, not so serious, and oh so much more fun! Your entire notion of style can be set free!

In the theater, when an actor breaks character and addresses the audience, it's called breaking the fourth wall. It can be startling because it disrupts the illusion created by the actors and the audience. The same is true of this quasi world we've collectively created here on Earth. We take on roles that become our identity, but unlike the stage actor, we believe

we literally are the characters we are portraying, forgetting who we really are—spiritual beings having human experiences. Some people take their roles so seriously that they are willing to kill in the name of staying true to their character.

Most people don't want to awaken from the illusion. That's why drag queens make a lot of people feel uncomfortable. Drag queens are essentially making fun of the roles people are playing. And in doing so, "drags" have become experts at parody, satire, and deconstructing social patterns. In the drag world, we might say "she" when we're actually talking about a "he," or we might laugh hysterically at a sad, depressing scene from an old black-and-white melodrama. Again, it's a survival technique to avoid getting sucked into the "seriousness" of all the drama. Like Mary J. Blige says, "No more drama."

And it's not only drag queens who have blown the lid off culture's lunacy and hypocrisy. Comedians, rock stars, and even Bugs Bunny have built celebrated careers on irreverence and challenging the status quo, but drag queens aren't praised as such because they carry the burden of shame inflicted on feminine men by a masculine-dominated society. Feminine behavior in a man is seen as an act of treason in a masculine culture, as opposed to in ancient cultures that relied on drag queens, shamans, and witch doctors to remind each individual member of the tribe of their duality as male and female, human and spirit, body and soul.

I needed to start off with this monologue so you could understand my approach to life, which is the following:

Don't take life
too seriously.

Love

Very little
is off-limits,
but draw the line at being unkind.

Do whatever you want,
just so long as
you don't hurt anyone
else in the process.

yourself.

Live your life with
no restrictions.

To truly create your best life ever, you must begin the work from the inside out. You must liberate yourself and clear away the old mental habits that block you from moving forward. Style is a celebratory expression of your life force. You must approach it with a sense of joie de vivre. Open yourself to all the possibilities! And remember to love yourself, because if you can't love yourself, how in the hell are you gonna love somebody else? Can I get an *amen* in here?

All the colors of the rainbow are there for you to use, but keep in mind that there are fixed ways the human senses (sight, sound, smell, taste, and touch) will interpret information (but those margins can be nudged with a quick and clever hand and a well-rounded knowledge of history). You must learn the rules first before you throw them out, and then by all means throw them out. The future belongs to those who have learned from the past. In the following pages, I have outlined tried-and-true techniques found on my quest for life, liberty, and the pursuit of style.

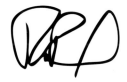

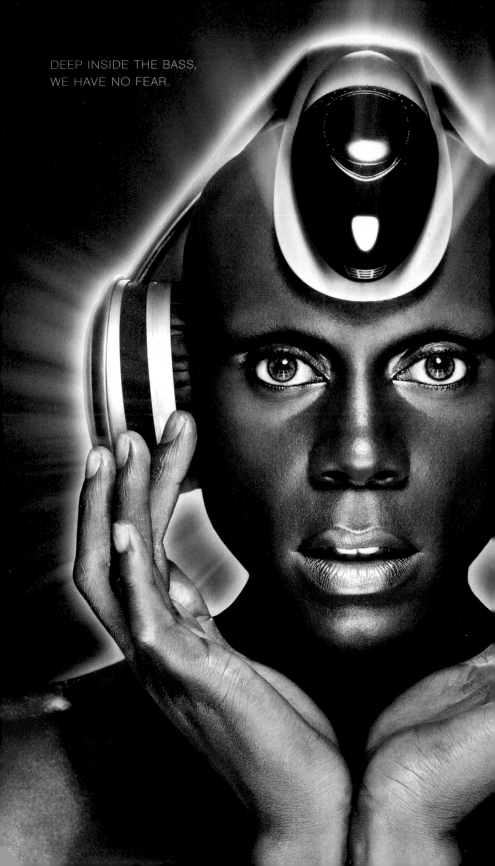

DEEP INSIDE THE BASS,
WE HAVE NO FEAR.

one

It's your *attitude,* quite frankly.

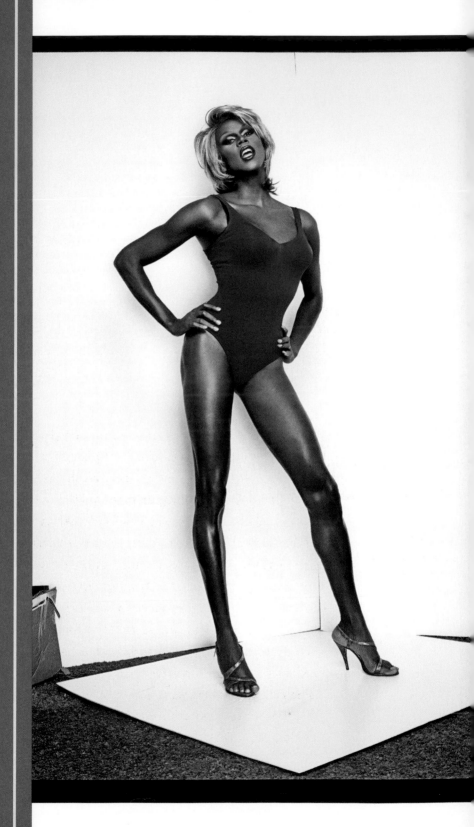

THE FREQUENCY
BETWEEN
YOU AND ME

aving a great sense of style
is more than being able to
put the right combination of
clothing together to look
clever and chic. It's more than having a keen eye
for home design and a knack for turning a simple
party into an unforgettable event. Having a great
sense of style also includes how well you're able
to love yourself, and the ease at which you
balance your ego with your spirit. Being elegant
and composed on the outside as well as the
inside takes conscious effort and vigilant
practice. Dealing with stress, disappointments,
and the myriad other problems that plague
modern life can be daunting, but not impossible

Rise up
and be
fearless

if approached from a foundation of self-love. That foundation is firmly rooted in the knowledge of who you really are. And who you really are is a spiritual being having a human experience. This isn't something you have to learn—this is something you have to remember. Because deep down, you already know it.

Your spirit is a frequency transmitting at this very moment. Some people have a strong, clear signal, and some people have a weak, obscured signal layered by many years of fear and self-loathing. A lifetime of being told you are ugly or stupid or unlovable will fade away when those layers are dissolved, and your ability to claim your greatness will emerge. Addictions, compulsions, and obsessions are a result of a blocked frequency. Clearing a path for your frequency to transmit freely is the key to revealing your own personal style, unique aesthetic, and inalienable freedom.

In these pages, I'll share with you some of the daily practices that have helped me keep my frequency clear. Like a beacon of light ready to sear through the dark night of the soul, your frequency is lying in wait for your beck and call. No more hiding, no more dumbing down. Rise up and be fierce! Fierceness is a deliberate decision to be clear, precise, and on point. Rise up and

be fearless, like a Maasai warrior. Stake your claim in this lifetime. Remember who you really are. Unleash the dragon and let—these—bitches—have—it!

SQUIRREL FRIENDS

San Diego is known for its sunny skies and beautiful beaches, and when I was growing up there I'd go to the beach as often as I could. I loved it. It made me feel free. Getting there took quite a bit of effort because my neighborhood was so far inland that I'd have to catch several buses before I reached the shoreline. The people in my neighborhood rarely ventured out there. In fact, they didn't leave our neighborhood much at all. They preferred to stay in the comfort of the hood, thank you very much. But at thirteen, I had a desire to explore, and no amount of bus hopping would deter me. I always thought it was weird that so few people from my neighborhood ever enjoyed the most celebrated feature of living in Southern California, but hey, that wasn't gonna stop me from going. Upon my return from the beach, the neighborhood kids would get on

my case by saying things like "Oh, you must think you white or something!" or "You think you better than us?"

This was a real eye-opener. I wasn't prepared for the negative reaction my seaside odyssey would evoke. It's then I realized: I'd have to learn to navigate around other people's threatened egos—particularly when I didn't buy into their small, limited view of the world. Back then, my choices were to dumb down or keep quiet and play possum. I learned to do both until I could get the hell out of there, which happened a couple years later when I moved to Atlanta, Georgia.

If you have goals and the stick-with-it-ness to make things happen, people will feel threatened by you, especially if your goals don't include them. They believe that if you take a piece of pie, then that leaves less pie for them. Seeing you follow your dreams leaves them realizing that they're not following theirs. In truth, there is unlimited pie for everyone!

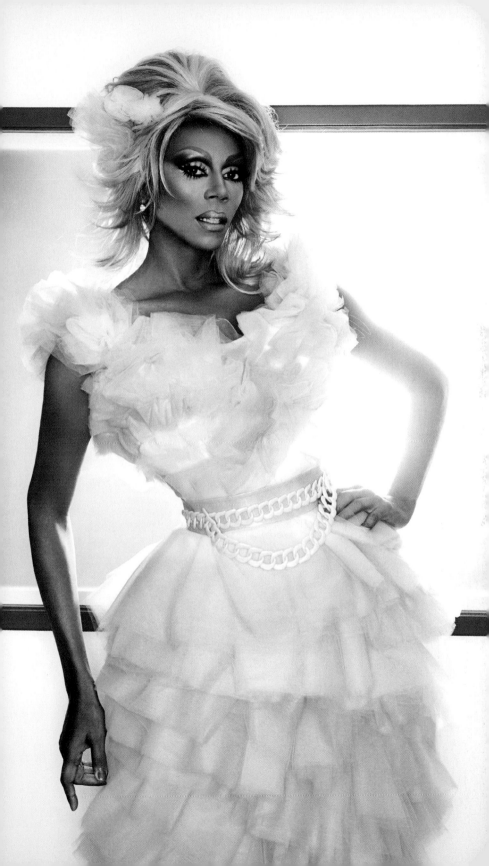

I wish I could say that scenario didn't repeat itself once I left San Diego County, but unfortunately it did, many times. From Atlanta to New York and back to Cali again. Every single time my star shined brighter or an opportunity arose for me, the current friends in my life would barely disguise the resentment in their eyes. I could feel it. I could smell it. Of course, me being the eternal pleaser, I'd offer a hand and say, "Come, go with me!" or "Maybe I could get you a . . . ," but that trick never works. It got to the point where I wouldn't even share the good news of my career developments anymore. Strangely, they seemed happier to hear of my disappointments. Reminds me of a bunch of king crabs in a pot of boiling water—as one climbs to freedom, the others pull it down. So I worked out a plan for this kind of reaction. I developed an exit strategy and put it into play when the time came. I know it may sound cold, but I am talking self-preservation, baby.

My attitude toward friendship has remained the same. I will support and encourage you with all the love in my heart, but if it's not reciprocal, I gotta go. When the envy and negativity of others start to undermine your confidence, you have to find comfort in other places. If your friends are bitter about your success to the extent that they act out, don't expect them to change. They aren't evolved enough to understand that opportunity creates more opportunity. Move on. You'll make new friends who will be drawn to your frequency, and you to theirs. You cannot thrive in toxic relationships. This is an unfortunate fact of life, and the sooner you recognize the tactics of the threatened ego, the faster you'll be able to sidestep its emotional land mines.

You cannot *thrive* in toxic relationships

CREATING OPPORTUNITIES

I was inspired to catch the bus to the San Diego beach because of my desire for beauty, my innate curiosity, and my tenacity to try something new. I approach my career in the same way. I've always loved music, laughter, textures, and color. I love movies, books, and wildly creative people. So, naturally, I set out to create a life for myself that included all these things. And I would have done so whether I was paid for it or not. In fact, for the first ten years of my career, I was barely able to pay rent. But attention was always paid to what inspired me. You never know where that next big idea is coming from. And you'll never see it coming if your heart and mind are not open.

In 1996, I was asked to present at the first televised VH1 Fashion Awards. I happily agreed,

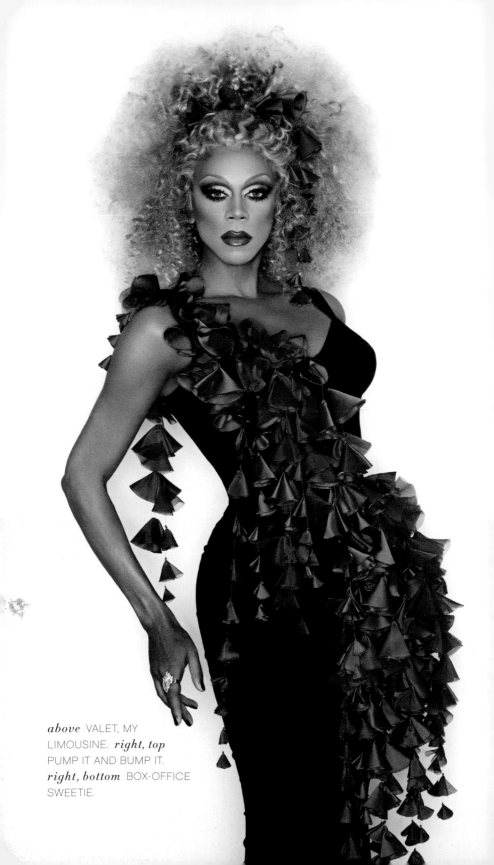

above VALET, MY
LIMOUSINE. *right, top*
PUMP IT AND BUMP IT.
right, bottom BOX-OFFICE
SWEETIE.

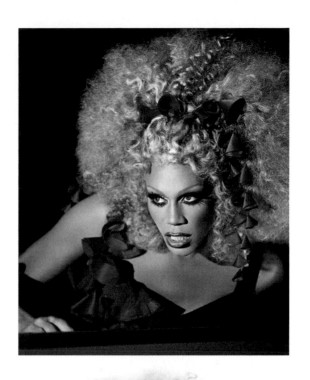
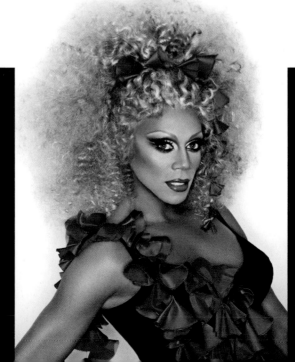

but was soon disappointed when I read the script they had written for me. The tone of it was bitchy and mean—a trap most writers fall into when they're trying to emulate "queen's speak." I told them that my shtick is sassy, not bitchy. It's a fine line a lot of people have a hard time deciphering. I asked if I could have a crack at the script and they said yes. When I presented the award, the bit I wrote brought the house down. I can still see the faces of Tina Turner, Iman, and Elton John laughing hysterically. The next day, I got a call from VH1 offering me my own talk show.

Had I not taken a chance, the opportunity would never have come up. Sometimes you have to wait for opportunities, but most times you have to create them for yourself. If you're waiting for an opportunity, make sure you're prepared when it happens. Learn your craft, and know thyself. If you're creating opportunities, you're planting seeds, nurturing them, and then planting some more. When the going gets tough, the tough reinvent. Life requires that you reinvent yourself every seven years. Whether it's in friendships, in business, or in how you see yourself.

Having reached local stardom in the underground club scene of Manhattan, I set my sights on conquering the mainstream pop world. My plan was simple: create a fun, club-kid image that wouldn't frighten Middle America—more androgyny than drag. I naturally assumed the drag persona that had made me famous downtown wouldn't play so well in Peoria. Months passed. I got a few gigs, and audiences seemed to like it all right, but their enthusiasm was nowhere near the jaw-dropping reaction I was used to getting

Learn your
craft and
know thyself

when I performed in drag. So far, my mainstream
reinvention was bombing. I needed a miracle.

Then I had an epiphany. Why couldn't I
become a mainstream pop star in drag? Who
said it couldn't be done? Was it all my own
limited thinking that prevented me from moving
forward? The answer was a resounding *yes*.
All along I thought it had been the world blocking
my way, but in reality it was me. I was the one
schlepping yesterday's limited view of myself into
today. *If I was willing to change my mind, I could
change the world!* With that realization, I felt the
earth shift. It was as if ancient stone walls started
to crumble and crash down, and the magical
words *open sesame* billowed through my head.
From that moment on, my life would never be the
same. Not only did I go on to become the world's
most famous drag queen but I also discovered
the secret of manifesting miracles by changing
my mind.

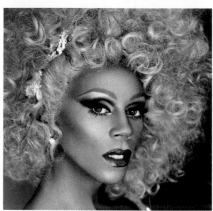

left DON'T BE JEALOUS OF MY BOOGIE. *right* I DIDN'T CHOOSE THE GAME. BOO . . . THE GAME CHOSE ME.

FIRST IMPRESSIONS

We're all familiar with the idea of making an entrance. It's not just pertinent to the Broadway stage or the fashion runway. When faced with auditions, job interviews, first dates, or really nailing it in a twenty-minute presentation, the first impression means everything. And it may be the only chance you get. Being six foot four pretty much ensured that I wouldn't go unnoticed walking into a room. But I need more than just my height to make a lasting impact. And you better believe there are bona fide techniques to make the best first impression. How do you want other

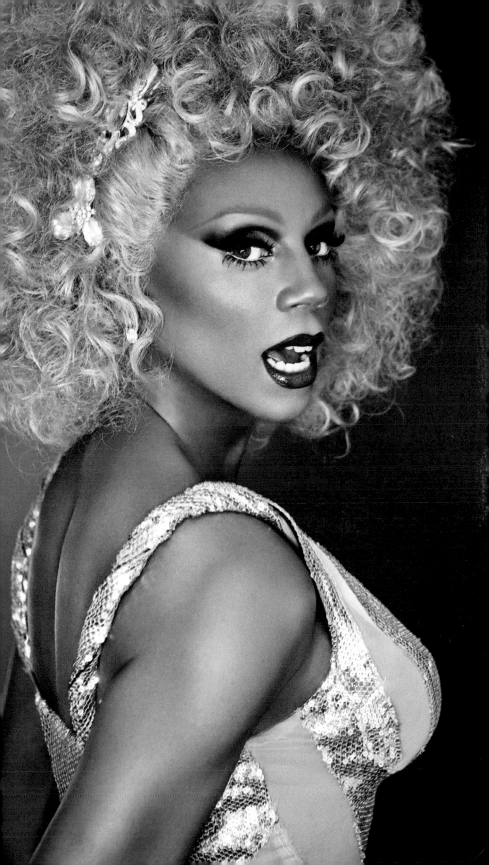

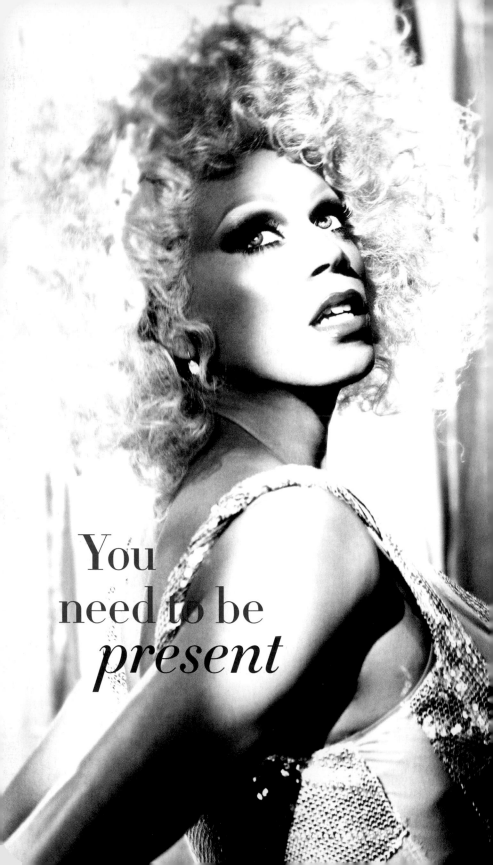

You
need to be
present

people to see you—approachable, energetic, comfortable in your own skin?

First off, if you want to be in the flow you need to be present. When introduced to people, firmly lock hands with them and make direct eye contact as you shake. It says not only how present you are but also that you acknowledge their presence. Weak handshakes never go unnoticed. It says the person is not in the moment.

In a social setting, pay attention to other people when they're speaking, while maintaining an awareness of everything that's happening in the room. This is tricky because you don't want to appear to be like those Hollywood types who are always looking past your shoulder for someone more fabulous. *Yuck.*

Know that energy attracts like energy. You'll want to attract people who resonate a certain vibrancy. No one can be drawn to you if you're not consciously transmitting a flow of energy. If that flow is reciprocal, the exchange can be intoxicating. Really connecting with someone on an energetic level is like a drug. This takes a certain amount of comfort in your own body. And it takes risk, because some of what you attract won't interest you.

TARDY TO THE PARTY

Being late is never clever, cute, or cool. I used to procrastinate till the very last minute to make it to appointments. Even when I had plenty of time. I was always speeding through traffic with my heart pounding and putting everyone on the road in danger—myself included. I knew being late all the time made me look bad and was completely disrespectful to the people waiting on me, but for some reason I just couldn't stop it. Finally I had to ask myself: What payoff am I getting from being late all the time? We humans aren't motivated to do anything unless there's some kind of payoff. I got honest and the answer came. I was selfishly addicted to the adrenaline rush and the thrill of trying to beat the clock. Once I blew the lid off myself, I started enforcing a no-tardiness rule. I'd leave for appointments early, even if it meant I'd have to arrive early and wait in the parking lot. The amount of respect you have for others is in direct proportion to how much respect you have for yourself.

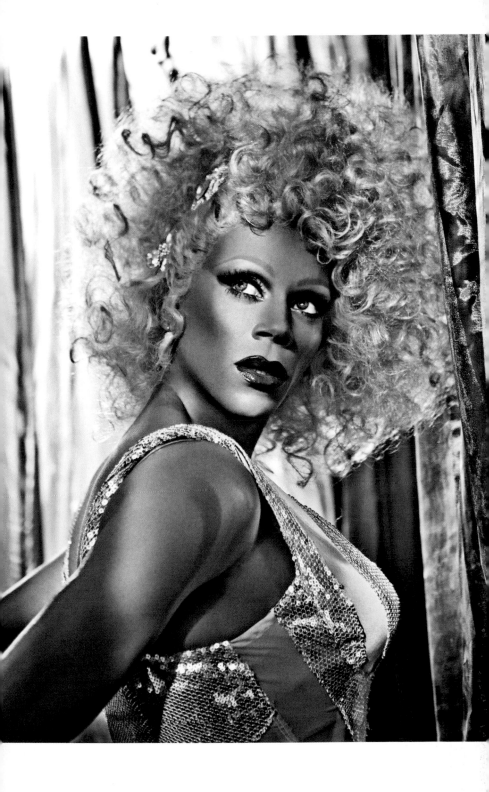

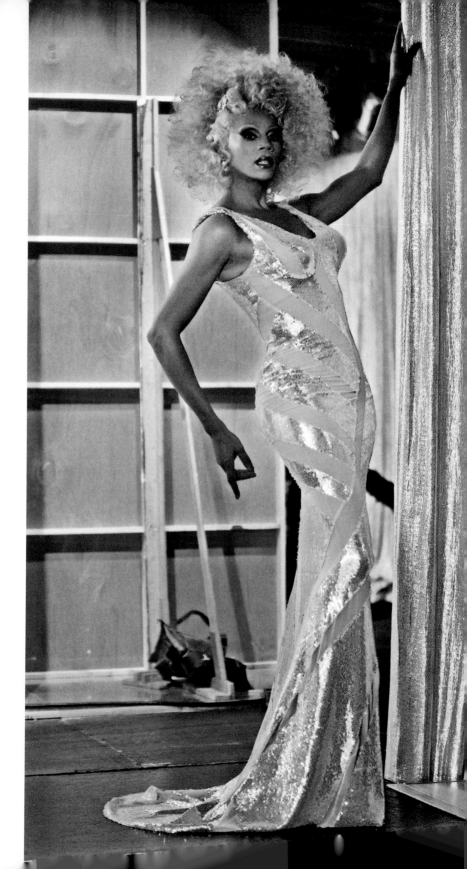

THE SABOTEUR

Most of us have experienced hitting rock bottom. If you're fortunate enough to live a long time, it can't be avoided. Bottoming out forces you to ask the tough questions: How did I get myself in this position? Did state of mind contribute to my predicament? What am I getting out of being so negative? Sinking into negativity means your ego is looking to justify a multitude of sins, namely, the sin of laziness. Negativity is basically laziness. It takes a lot of hard work to remain positive, but positivity always pays off. This is where stepping outside yourself becomes important. Retrace the path that led you awry and it will lead directly to The Saboteur, your inner critic, aka your ego mind. The Saboteur has been practicing a strenuous workout regimen your whole life, but it's never too late to counterbalance it with positive musculature.

Positivity
always
pays off

You can start by not putting other people down. Gossip and saying negative things about other people is a result of your self-loathing projecting outward. Don't feed into it! When you see that tourist standing in baggage claim, the one wearing the misguided, Day-Glo tracksuit, cut them some slack! You criticizing them is really the same as you criticizing yourself. Accept that misguided Day-Glo tracksuit and you will dodge a lethal boomerang. What you find fault with in other people is usually what's bothering you about yourself. It's an endless cycle if you let yourself fall into that negative pit.

Similarly, if people are saying nasty, hurtful things about you, don't allow your ego to co-opt the situation by taking what they're saying to heart. Know that what they're saying has nothing to do with you. Again, it's them projecting their own self-loathing and fear. Say this out loud: *What other people think of me is none of my business.*

MAY THE FIERCE
BE WITH YOU

Growing up, I always thought the sulking poseurs wearing all black and smoking filterless cigarettes had their shit completely together. They looked so rough and tough and bored with everything. Eventually, I realized how hard they were working to have me and everybody else assume that. It was a full-time job to appear that cool. But it was all superficial. A lot of people who feigned fabulousness, like Edie Sedgwick and Sid Vicious, never learned in life to transcend the inner demons that would eventually destroy them. Theirs was all confidence on the outside. Chip away at those flawless facades, and you often find a very scared child with an insatiable emptiness.

Today, kindness is the new cool. Being kind illustrates the highest level of consciousness and deliberate optimism. Being kind says: *I know the material world is an illusion and I choose to recognize the beauty, innocence, and The Source in everyone.* Pollyanna knew she had a choice

Kindness
is the
new cool

between the dark side and the bright side, but she consciously chose the latter because joy is far more interesting than pain. And it takes a great deal of strength to maintain.

I feel confident today because I've learned how to step outside of my pseudoself (my ego) and remember the truth of who I really am. My power isn't contingent on my bank account, the car I drive, or the rings on my fingers. My power comes from The Source, The Force, or whatever you want to call it. It's me, it's you, it's all around us. It doesn't stop where you start. By remembering that on a moment-by-moment basis, I'm able to have fun with colors and textures as a child would, and the importance of superficial things becomes laughable.

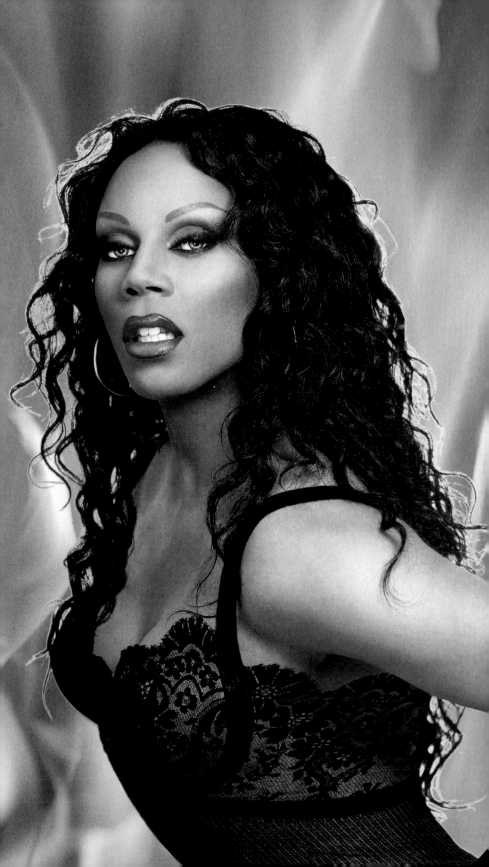

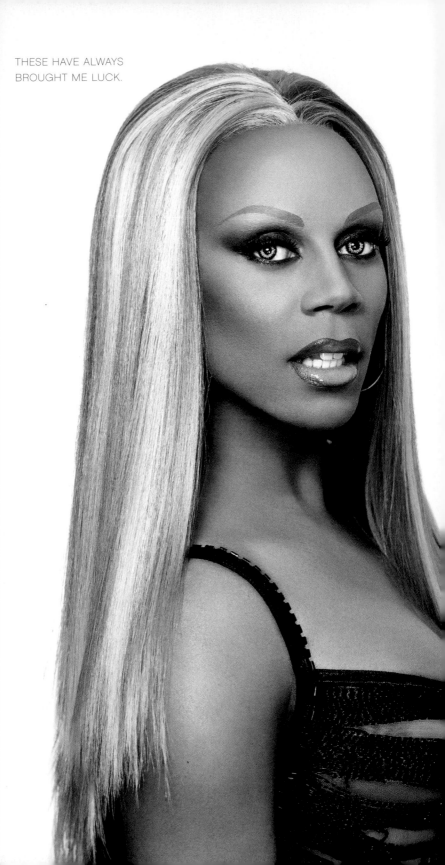

THESE HAVE ALWAYS
BROUGHT ME LUCK.

TWO

Give
me
body

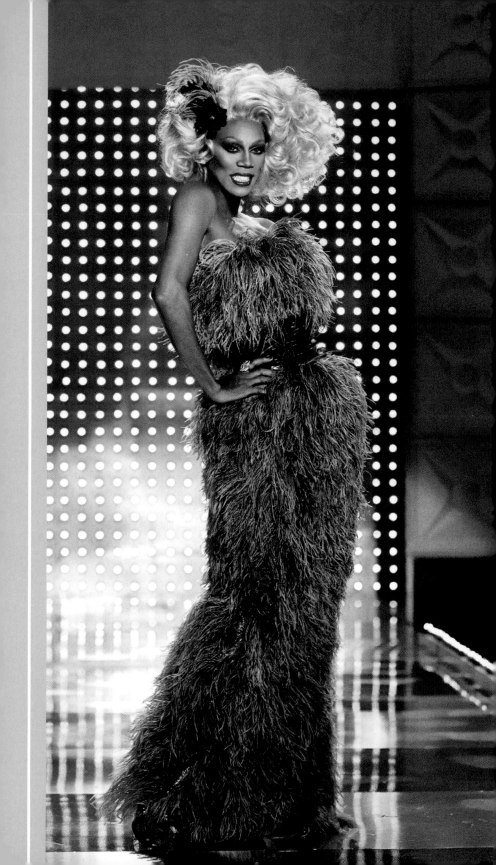

THE
DRAG QUEEN DIET

I used to joke that I was on the Supermodel Diet: a Tic Tac for breakfast, a Tic Tac for lunch, and for dinner, a glass of water—no Tic Tac. Truth is, I've never been a big food person. My weaknesses are sugary things and crunchy things. I have to be very careful with them because once I start eating those things I can't stop. I gravitate toward food that will give me energy without making me feel sluggish. Combining food is a great way to ensure your digestive system doesn't get slowed down by foods that don't digest at the same rate. These are not new concepts. "Fit for Life" and "Somersizing" are two of the many food plans that use this philosophy.

My secret weapon is to eat small portions and to eat at home as often as possible. And I always eat (at home) in advance of going to a dinner party. That way I won't be tempted by the party food. Another trick is to carry roasted unsalted almonds in my bag just in case I get a dip in energy while running errands. Don't get me wrong—it's not a crime to have food drenched in salt, sugar, and enriched flour every now and again. The problem is it triggers me to crave more of it. And that's an endless cycle I'd rather not be on.

Breakfast

I don't eat anything after the sun goes down, so by the time I wake up in the morning I'm ravenous. Breakfast is literally breaking the fast of the night before. By setting up a morning eating pattern, your body will know it's okay to burn fat while you sleep because there will be food upon awakening. I never get bored with old-fashioned oatmeal for breakfast. I put cinnamon, Splenda, dried cranberries, and rice milk in a bowl of dry oatmeal and cover it with plastic wrap. Then I put it in the microwave for two minutes and fifteen seconds. While it's cooking, I'll drink a glass of water and put the coffee on.

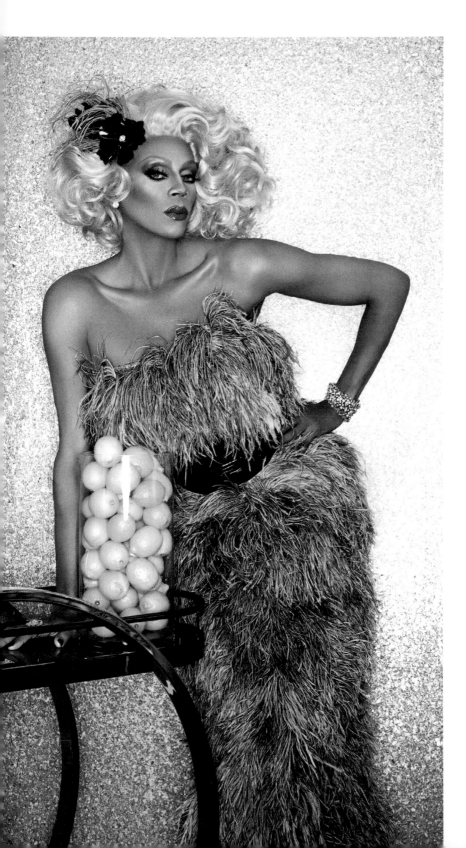

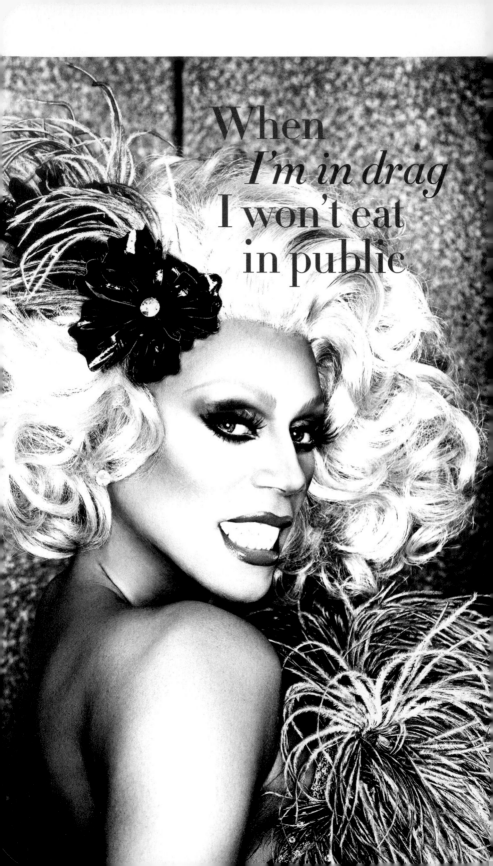

When *I'm in drag* I won't eat in public

When I'm traveling, I order an omelette with vegetables, bacon, and cheese, and black coffee. I have them replace the potatoes with tomatoes, and no toast or fruit. Fruit is a lovely breakfast, but it must be eaten with no other type of food (I break this rule by having dried cranberries with my oatmeal). I'm also a big fan of burned whole grain toast and black coffee for breakfast, but the toast must be eaten dry or with vegetables, but nothing else. No oil, butter, jam, or meat.

Lunch

Grilled fish or chicken with vegetables or salad or a cheeseburger with *no* bun. Sometimes I'll have soup. Room-temperature bottled water.

Snack

A yogurt or some almonds or sunflower seeds. If I have some fruit, it's never with other foods.

Dinner

Grilled fish or chicken with vegetables or salad or a cheeseburger with *no* bun. Sometimes I'll have a steak. Room-temperature bottled water.

My Cheat Food

Burned toast and apricot jam. But again, the problem is it triggers me to crave more of it.

When to Eat

When I'm in drag I won't eat in public. When I'm out of drag I prefer to not eat in public. Ever been to a dinner party where a guest insists on standing and talking as they eat? *Ew*, gross! Food flying out of their mouths! Or on the subway when somebody whips out some Chinese takeout and it smells up the entire car? Double gross! Food should be eaten deliberately at a table. I like to think of my appetite as a fire that constantly needs wood. Eating small portions of minimally processed food every three to four hours is best. That regimen sends a message to your metabolism that it's okay to expel fat. I also stop eating before I get full. I really can't stand that uncomfortable feeling of being stuffed.

Workout

I go to the gym five days a week. I do some core training and light weights, but my favorite thing to do is the cardiovascular workout on the machines.

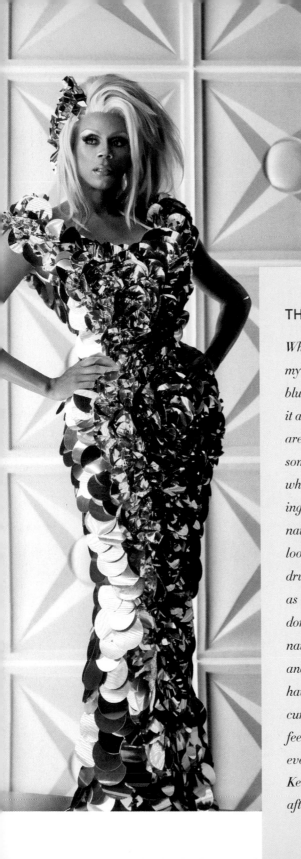

THROW YA HANDS UP

When I'm filming, I change my nail color for every outfit—blue, pink, red, black—I love it all. Those long dagger nails are still a sign of status in some communities, but everywhere else it's just about having nice oval or square-filed nails and a strong color that looks modern. And the drugstore brands are as good as the expensive ones. If you don't have the time to do your nails—and this applies to men and women—make sure you have a manicure and pedicure and keep your hands and feet looking clean and smooth, even if there's no polish. Keeping your nails looked after is a true sign of self-love!

I bring my iPod and get my heart rate pumping to some serious boom-boom BPMs. Regulating my food intake keeps me from getting fat, but working out gets my metabolism going. I never forget to do extensive stretching before and after the workout, and throughout the day. If time permits, I'll also add another physical activity to my day, like biking, hiking, country-line dancing, or roller-skating.

Don't Smoke Cigarettes

I smoked for nearly thirty years, and it's been six years since I quit. Kicking the addiction to nicotine was the easy part. Stopping using them as an emotional pacifier was the most difficult part. Looking back, I realize how much I used smoking to block my feelings and put up a wall around me. Today, I want to feel my feelings. I want to be here for the experience. I've learned how to process the sensation of feeling frustrated, which used to be a trigger for me to light up. I still get frustrated and I still get triggered, but now I talk myself off the ledge, so to speak, by retracing the emotional steps that led me there. It's usually a misperception on my part that triggers me to want to get lost in a cloud of smoke. I've learned to remind myself to breathe and that I have options. I remind myself I am not that scared little boy anymore, and that whatever is making me feel trapped (traffic jams, computer malfunctions, book deadlines, etc.) is negotiable. I don't have to burn the school down just because I didn't do my homework.

MEDIA DIET

Be very careful of what you allow to infiltrate your consciousness and subconsciousness. When you watch too much television, you'll start to feel inferior from all the commercials hard selling the idea that you're not complete unless you buy their product. It's the only way they can get you to buy something you don't need. The ad agencies appeal to your fear of not being wanted or loved. It's the same with the local news. They get you to stay tuned with a constant stream of fear tactics. I once heard a local news teaser say, "Coming up on the news at five: find out how your carpet could be killing you." It's as if our culture is addicted to fear and the flat screen is our drug dealer. Don't allow that crap into your head! It only supports the idea that the world is out to get you. The world is not out to get you, but your ego's appetite for fear is. My advice is to not watch the news at all. Read the news on the Internet or in the newspapers (remember them?). That way you can avoid all the fear hysteria the TV news is so keen on inducing.

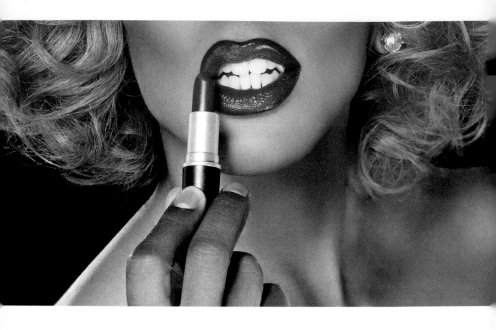

RU-DIMENTARY

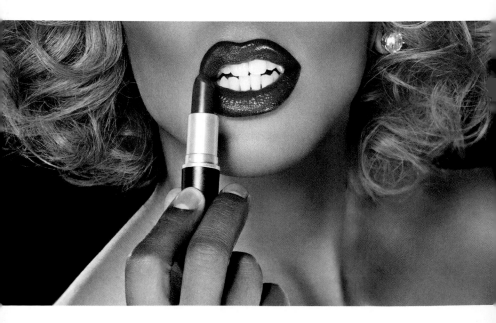

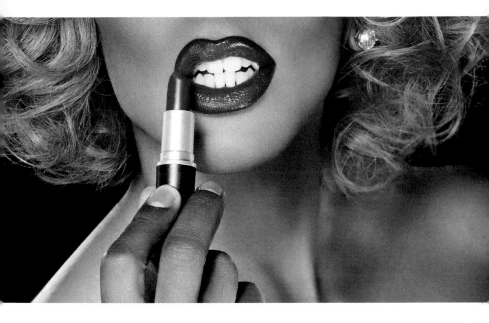

BEAUTY

Your state of mind
eventually shows up
on your face.

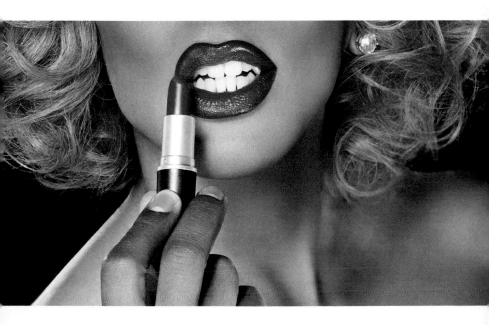

THE CLOCK
ON THE WALL

Everyone's obsessed with not aging in our culture, and quite frankly the whole subject is a complete bore. Yes, this body will fall apart and really embarrass you in the process. But you can be proactive and not smoke, eat food that is not so damn processed, and stop holding grudges. Illness in the body is the result of negative thoughts manifested. To give you an example, when I think of biting into a juicy Florida orange, my mouth begins to salivate. All thoughts manifest in the body and on your face eventually. Be mindful of your thoughts. Think peaceful and forgiving thoughts and be beautiful. If you can't manage that, then by all means, get your mug pumped and pulled, poked and resurfaced.

1. **Love yourself and be kind. Allow other people to love you.**

2. Don't smoke. It's the single healthiest choice you can make for yourself.

3. **Make love, exercise, dance, hike, and bike. Energy creates energy.**

4. Take good care of your teeth. Floss and brush after every meal.

5. **Drink water, not soda pop.**

6. Moisturize all over. A moisturizer with sunscreen is even better.

7. **Get regular full-body massages.**

8. Meditate. Connect to The Source.

9. **Get enough sleep. Your body will let you know how much you need.**

10. Create a mature relationship with food. Make time to explore the grocery store and farmers market.

11. **Use an eyelash curler, unless your eyelashes curl naturally.**

12. Be of service. Volunteer. It is the key to happiness.

HAIR TODAY, GONE TOMORROW

They can put a man on the moon, but they still can't figure out a painless way to make hair stop growing! I use a disposable razor to shave the areas on my face where the hair hasn't been electrolytically removed. Yes, I've had two and a half years' and twelve thousand dollars' worth of electrolysis, and I still have to shave my face. Electrolysis works, but it takes forever to finish an entire face. I'd love to do more, but I'm on the road too much to allot the recovery time needed. Did it hurt? Yes, but not as much as laser hair removal. I couldn't tolerate the laser.

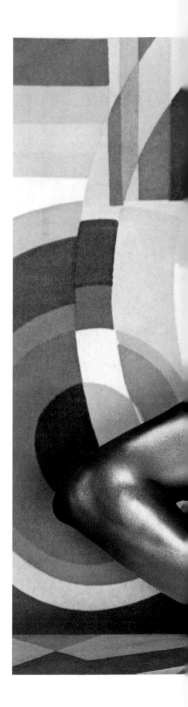

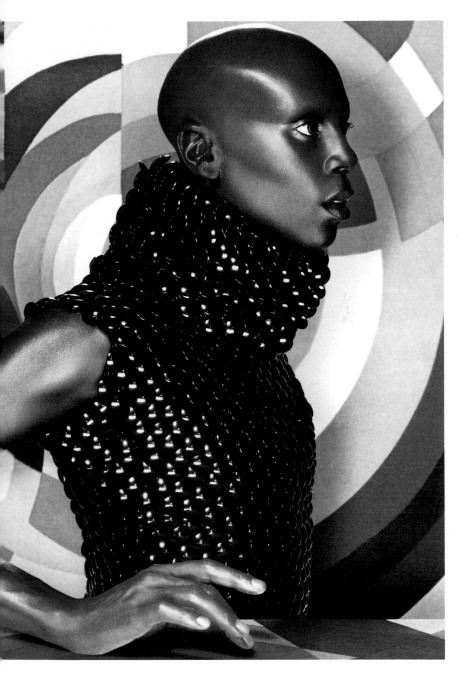

AS A KID, I FELT LIKE THE LITTLE BOY WHO FELL FROM EARTH.

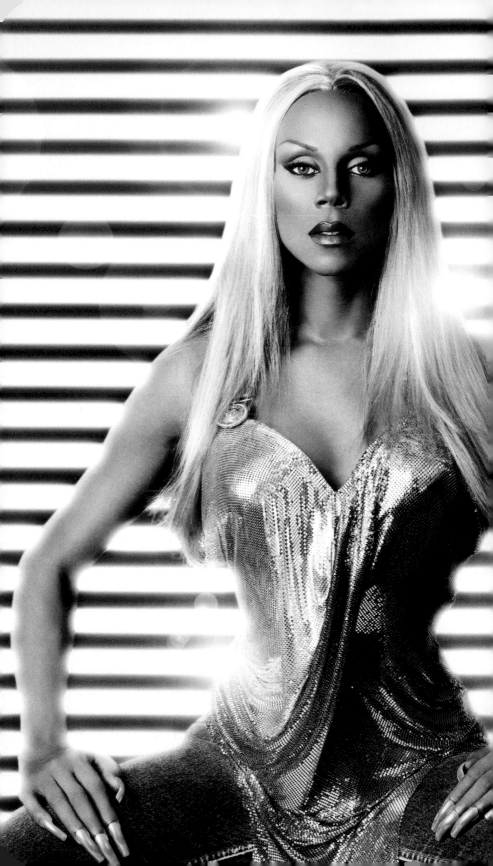

MY FIRST COLONIC

My colonic irrigation was a complete success!
Free at last, free at last. Thank God almighty, I'm
free at last!

Before my colonic irrigation appointment, I
imagined it would be done in some seedy dive
with live chickens roaming around a backroom
featuring overhead fluorescent lighting. I
imagined the technician as some illegal alien
with yellow dishwashing gloves and a two-year-
old toddler on her hip. She'd come out from
behind raggedy curtains and scream, "Who
next!" Then the lady-poo technician would lead
me to some smelly, damp hole in the wall with a
TV in the corner blaring The People's Court.

I had imagined she'd stick a long metal
prong thing up my ass, like the ones they use to
do liposuction, and aggressively scrape the walls
of my lovin' oven. Or even worse, she'd fill me to
the brim with cold sudsy water using one of those
high-powered hoses from the do-it-yourself
carwash! Unable to hold it in, my bowels would

I'm *free* at last

explode all over the room—leaving me humiliated and emotionally scarred for life. Oh, the horror!

Add to all of that the embarrassment our culture has with anything to do with bodily functions. Yes, I'm talking about "shit shame." I'm pretty sure that shit shame is what kept me (and most people) from doing a "high colonic" before. But it was the promise of erasing my past from the inside out that kept me intrigued. Who could blame me for wanting to get rid of all the chewing gum I swallowed as a kid? Chewing gum that was presumably still stuck in the nooks and crannies of my intestinal lineage.

Instead of the horror story I imagined, the facility was a clean street-level medical office with holistic touches here and there. New Age music and incense created a calm, sanctuary-like feeling. A serene Asian woman named May led me to a room that was not unlike a doctor's examining room, except the lights were dim. Everything was very clean. May's energy made me feel very safe, comfortable, and relaxed.

After I changed into a hospital gown (no sequins or beads), May returned and explained what was going to happen. She showed me the never-been-opened, sealed-in-plastic sanitized hose that would be used. I got on the table and lay down in a

semi-fetal position on my left side. She then instructed me to insert the tip of the hose into my rectum. Well, I'm no stranger to ass insertion. "Just the tip?" I asked. I think May was very impressed with my unflinching finesse. She had me stop at only three inches! "That's all?" I said. I told her I could barely feel it! (Wake me when you're done. . . .)

With the hose securely up my poop chute, I eased onto my back, feet flat and knees up. Warm water entered through a canal in the hose, and after a few minutes, waste was extracted through another canal in the same hose. Mounted on the wall near my feet, there was a backlit monitor with two

TUCK EVERLASTING

Tucking is exactly what the name implies. After putting on a tight spandex G-string, push and flatten your penis and testicles in the direction of your anus. Simultaneously, hike up the G-string to hold your bits and pieces in place. Duct tape may be used, but first the area must be prepped by shaving. This is referred to as a "duct tuck." You too can achieve a fierce and flawless tuck depending on the amount of junk m' lady is packing. Tucking is not for the faint of heart. It can be very painful, so be careful crossing your legs. See you at the pool!

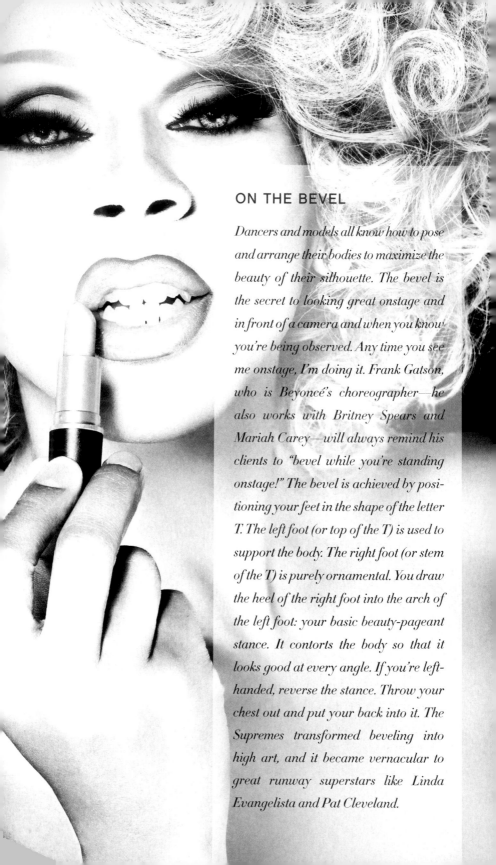

ON THE BEVEL

Dancers and models all know how to pose and arrange their bodies to maximize the beauty of their silhouette. The bevel is the secret to looking great onstage and in front of a camera and when you know you're being observed. Any time you see me onstage, I'm doing it. Frank Gatson, who is Beyoncé's choreographer—he also works with Britney Spears and Mariah Carey—will always remind his clients to "bevel while you're standing onstage!" The bevel is achieved by positioning your feet in the shape of the letter T. The left foot (or top of the T) is used to support the body. The right foot (or stem of the T) is purely ornamental. You draw the heel of the right foot into the arch of the left foot: your basic beauty-pageant stance. It contorts the body so that it looks good at every angle. If you're left-handed, reverse the stance. Throw your chest out and put your back into it. The Supremes transformed beveling into high art, and it became vernacular to great runway superstars like Linda Evangelista and Pat Cleveland.

I had…
a rootie-tootie
fresh-and-fruity
bootie

tubes that showed what was going in and what was coming out. I decided to not look at the monitor, but May did as if she were reading my future, and clearly my past.

May gently massaged my stomach and key pressure points on my arms, legs, and neck, while always reminding me to breathe. I focused on releasing my past and letting go of old resentments. It felt wonderful and there was absolutely no smell or leakage whatsoever.

Forty-five minutes later, it was done. My stomach felt flat as a board and my body felt light as a feather. I had finally achieved a rootie-tootie fresh-and-fruity booty! I started to fantasize about having a high colonic system installed in my house. I pictured myself backing that ass up every day, whenever I wanted. Holla! I asked if I could schedule an appointment for tomorrow, but May said to come back in three weeks. I can't wait until my next visit.

I was very proud that I had jumped a massive hurdle in my quest to eradicate shit shame from my life. Now I'm looking forward to eliminating shame (and shit) from other areas of my mind, body, and spirit!

PICTURE-PERFECT POSING

Trial and error is the only way to become a pro at posing for pictures. By doing several test shots in front of an unforgiving digital camera, you can scientifically deduce which side of your face is most photogenic, find your most flattering angles, dissect your facial symmetry, and most important, learn what not to do in front of a camera. If you want to use your body to its optimum performance level, you must know what your weaknesses are. Study your pictures and learn from them. Study other people's pictures and learn from them as well. I've been known to cut out my favorite photographs from magazines and bring them to photo shoots for inspiration and composition ideas. I will also have a full-length mirror set up next to the camera so I can really work my best angles. Research the great masterpieces of art and sculpture to learn how to hold your body in a position that's pleasing to the human eye. Pushing your shoulders down and keeping your neck as elongated as possible is a great technique used throughout the ages. Of course, body composure is important, but equally as important, if not more, is what you have going on behind the eyes. I like to imagine the camera lens is one of my close friends or someone I have a crush on. Being conscious of your lighting is also a major factor in having gorgeous photos taken. Legend has it that Marlene Dietrich got up on a ladder herself to properly position her lights.

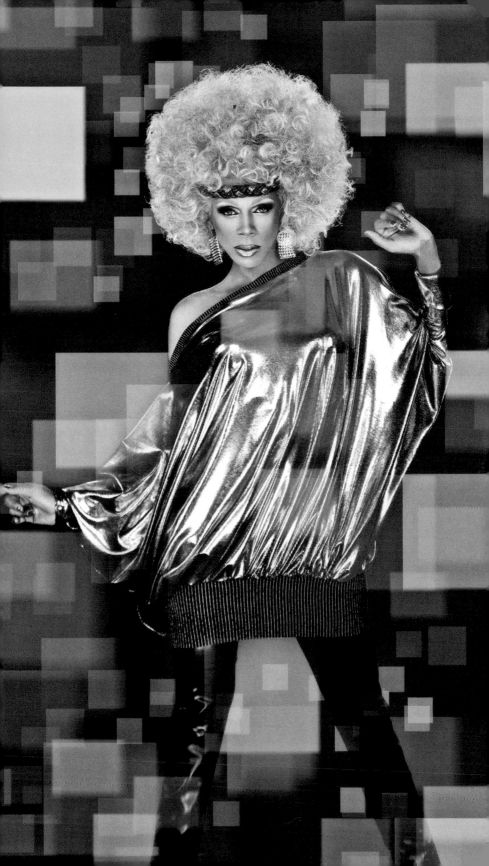

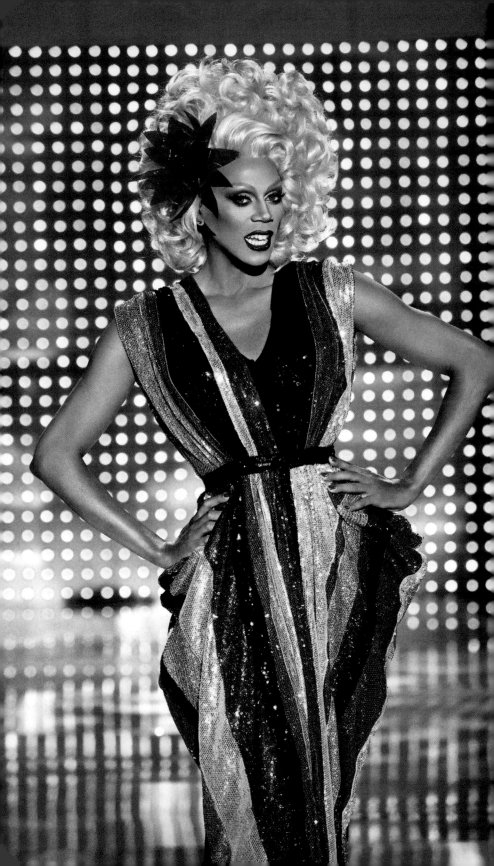

Stand up
straight

WORK THE RUNWAY, SWEETIE

You have to stand up straight to even begin to develop a strong walk. And oddly enough, it doesn't come naturally to most of us. It's important not to dumb yourself down, not to scrunch down, not to do anything down. Breathe when you walk, and you'll be present, like in yoga. It sounds so simple—but very few of us know what it means. No one knows more about walking than runway models. Carmen Kass, Beverly Peele, Naomi Campbell. Yasmeen Ghauri, a supermodel from the nineties, had the most gorgeous walk. She would swing her left hand out when she sauntered down the runway— it looked like she had a ball-bearing swivel to her hips. Go online and study fashion shows if you really want to perfect a great walk. A good trick is to film yourself practicing: it will give you the data on where to improve.

RIGHT THIS WAY, SIR

Men can enhance their walk by being conscious of their chest while maintaining great posture. Don't do it like a WWF wrestler; make it natural. Keep your hands by your sides and imagine you're holding a pencil in each hand. The pencil should be pointing straight out in front of you. If it is, that means your chest, back, neck, and shoulders are all in position, showing off your muscles to their best advantage. When an animal sticks its chest out, it's dominant. We can learn a lot from animals. After all, we're animals too.

left PAINT A SMILE UPON MY FACE. *below* HEAD TO TOE, LET YOUR WHOLE BODY TALK!

THE IMPORTANCE OF POSTURE

Walking tall with your chest out and your head held high says you have earned the right to stomp and pummel this particular piece of real estate. Straighten up and fly right, baby. Be conscious of your posture at all times. Even when no one is watching. Heels force you to walk more deliberately, prompting you to align your body and improve your posture. This is one of the reasons runway models have such great posture. Positioning yourself in the best possible presentation sends an instant message that your relationship with your body is healthy. Slouching shoulders and a hunched neck says you are ashamed and would rather fade away. Yoga and Pilates help immensely with posture.

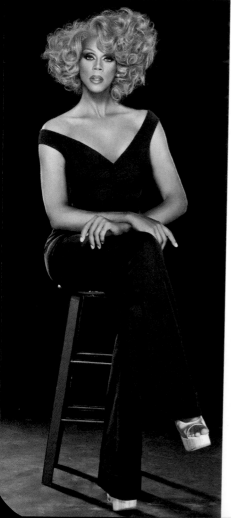

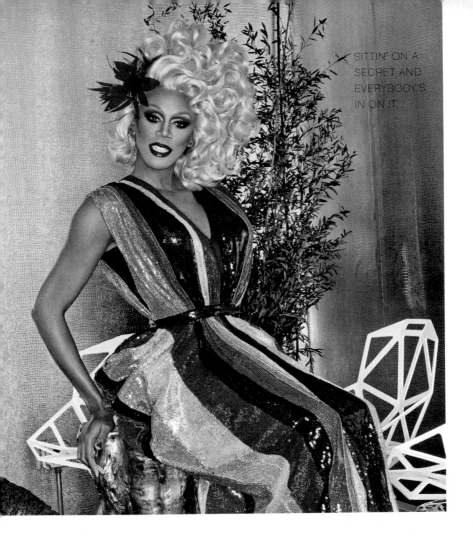

ARE YOU A PADDED QUEEN?

If you want that curvaceous look, I'll meet you at the foam-rubber store. The foam rubber is trimmed down with a knife or scissors for the correct roundness and size. Some of the more industrious girls use a power sander! Work! It's generally carved into the shape of continental Africa. The pads are then worn underneath support hose to accentuate hips and buttocks. I wear a body shaper that's made out of girdle material over the pieces to secure and smooth my pads. For a little something extra, add a pair of panties with the booty pads built in! You can find those online.

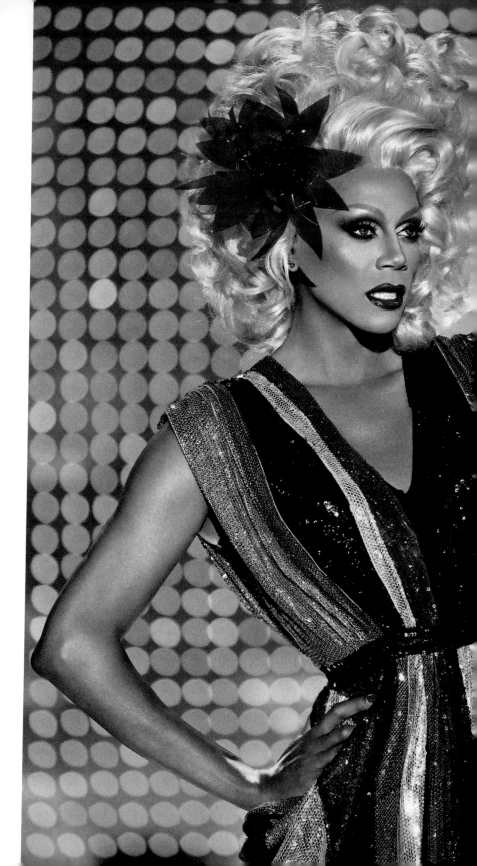

In the real world, men
love curves!

STARRBOOTY, BABY

You don't see many examples of truly curvy beauties in fashion magazines because the truth is that magazine editors and fashion designers know clothes present better on those "hanger bodies." But in the real world, men love curves! The women we consider the sexiest are Beyoncé, Eva Mendes, Jennifer Lopez, Scarlett Johansson, and Jessica Biel. All of these knockouts have real curves. And they aren't afraid to show them. Don't hide your curves! That 34-26-34 ideal of the bombshell shape is what biologically hypnotizes men. One of the best ways a woman can really highlight her curves, besides using a push-up bra, is by wearing a corset or a waist-cincher. You can buy corsets and waist-cinchers online or at shops like Frederick's of Hollywood and Trashy Lingerie, and not only do the sight of these secret weapons turn men on to the extreme but they also finesse your waist and hips into the stuff dreams are made of. Remember: big bust + small waist + sexy hips = goddess!

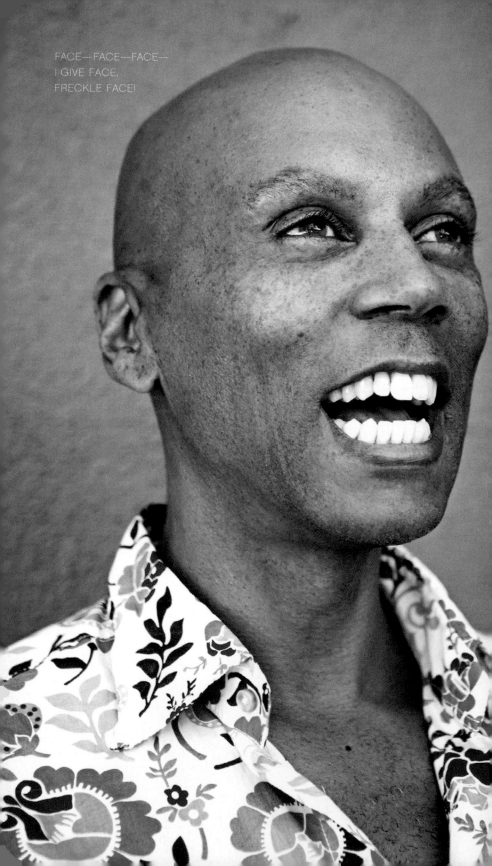

FACE---FACE---FACE---
I GIVE FACE,
FRECKLE FACE!

Wake up

to makeup

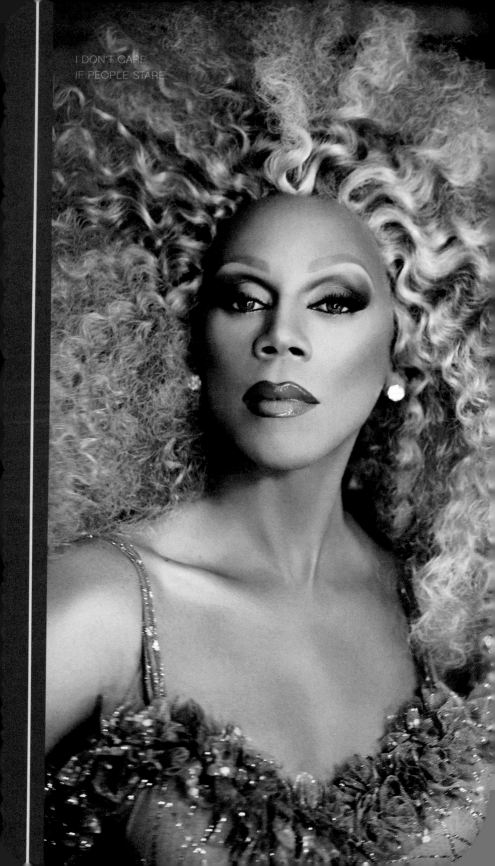

I DON'T CARE
IF PEOPLE STARE.

THE RU ROUTINE

y friend told me that when she mentioned to her coworkers that she'd had lunch with me last week, they all asked if I had come in drag. Of course, she told them no, and that I'm only in drag when I'm being paid. Her story didn't surprise me. I hear it all the time. People assume I live my life in drag, but I don't. I think it's a lot easier for them to grasp full-time drag than part-time job. My guess is that people want to put you in a box with a pretty little bow because the reality is far more complex than they're willing to comprehend. I always thought it was quite obvious that my approach to drag is more wink-wink than the "look-and-feel-of-real."

People assume I live my life *in drag*

My workday on *RuPaul's Drag Race* actually starts at 4 A.M., when I wake up. I have breakfast, then I shower and shave my bits and pieces. Then I drive to the soundstage where we tape the show. Mathu Andersen, who has done my hair and makeup for the past twenty years, meets me at the set. He and I both get there at 6 A.M. Music is chosen. I've been doing "DJ Shuffle" with my iPod—music is highly important to my transformation ritual. My dressing room at this point has already been outfitted with the makeup and the wigs. Our lighting system is jerry-rigged—it's like the MacGyver style of lighting rigs. We've usually talked the day before about what costume I'm going to wear and the corresponding hair. Mathu usually preps the wigs a day in advance, because they take so friggin' long.

I start with a clean face and moisturize under my eyes only. Next, I swab the areas of my head and face that will be taped, using a special alcohol that's formulated for toupee tape. I prefer toupee tape (double-sided tape) rather than spirit gum to attach my lace-front wig and temporary face-lifts. Then I apply sticky side A of the toupee tape to the areas on my hairline that a lace-front

wig will be attached to; sticky side B will be peeled back and exposed later when it's time to attach the wig. I apply the tape to my temples and to my widow's peak area to avoid wig slippage. My hairstyles are heavy as hell and always consist of two wigs. And yes, bruising, welts, and some scarring can occur after five weeks of fourteen-hour days in drag. I thought you knew— drag ain't for sissies!

I use Mark Traynor temporary face-lifts to shape and smooth my face and eyes. They're clear plastic tabs that adhere to your face. They have little holes for attaching an elastic pulley, which then gets tied at the back of my head. I adhere the Mark Traynor elastic tabs to my cheek with toupee tape. My whole career is based on an intricate system of pulleys and lifts, smoke and mirrors! Essentially, I'll be yanking my midcheek area to the far ends of the Earth. And voilà! Instant face-lift. I also attach them under my ear to help define my jawline. With the tapes securely in place, it's time to apply foundation.

NOTE: Elastic pulleys don't get attached and tied back until the makeup is finished, and right before the wig is put on. Also, a powder puff is placed at the back of my head (like a yarmulke) to cushion the pulley and allow for a supply of

Voilà!
Instant
face-lift

blood to reach certain parts of my brain. Just enough to ensure I won't black out and hit my head on the floor.

When I'm filming the show, I shave my eyebrows off completely. That way I don't have to worry about concealing my bushy brows with a glue stick, which is what I do when I'm not filming and I'm on the road with my nightclub act. You know, I really wish someone had told me when I was younger, "Hon, shave those damn eyebrows off!" My career would really have taken off a lot sooner if I had. Unfortunately, when you commit to shaving off your eyebrows, you can easily look like a mental patient when you're not wearing makeup. Shaved brows offstage are *not* what I call "man-catcher." If you do not want to shave your

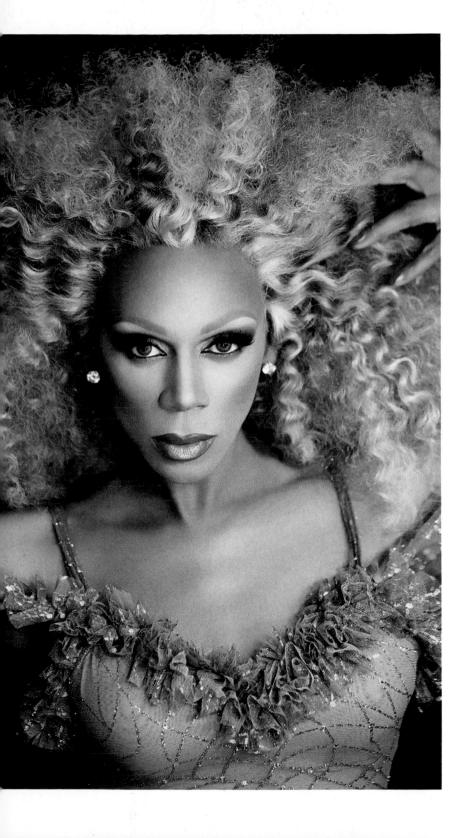

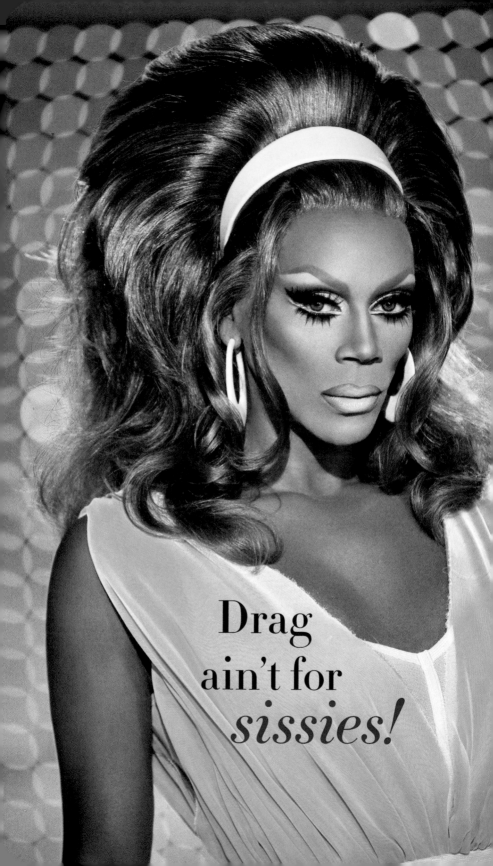

Drag
ain't for
sissies!

eyebrows, tweeze out the density of hair, so they will lie flat. Then get in there and cover them with some glue stick, getting them as flat as possible with a toothbrush and letting them dry. Then you apply full-coverage foundation over them.

Now we start on the face. Silicon primer comes first. It fills in pores and acne scars and gives a smoother appearance to the skin. Then I apply an anti-shine matte crème on the areas of my face that tend to get oily, like the bridge of my nose and my brow bone.

My face is now ready for full-coverage foundation. Mathu uses no fewer than five different shades of full-coverage foundation to re-create my face. The shades are all in the tone of my natural coloring, but vary from darkest to lightest. He uses the lighter shades of foundation to bring forward and emphasize certain features of my face, and darker shades of foundation are used to create depth and drama. This is your basic shadows-and-light story line. Keep in mind that it's not about brands; it's all about color tones, textures, and coverage. I require my full-coverage foundation to have warmth of color. Too many full-coverage foundations and powders for brown skin end up looking gray on camera. It's a good

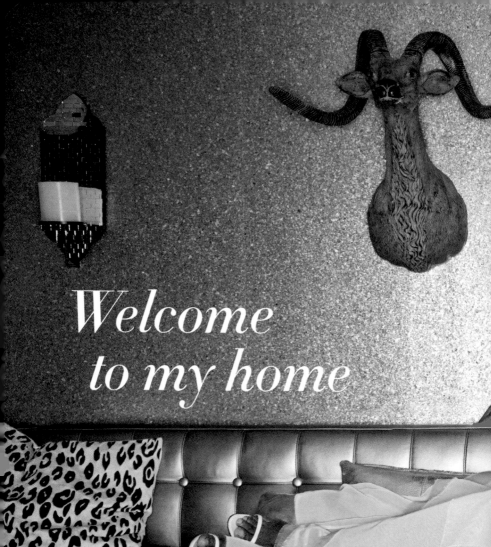

Welcome
to my home

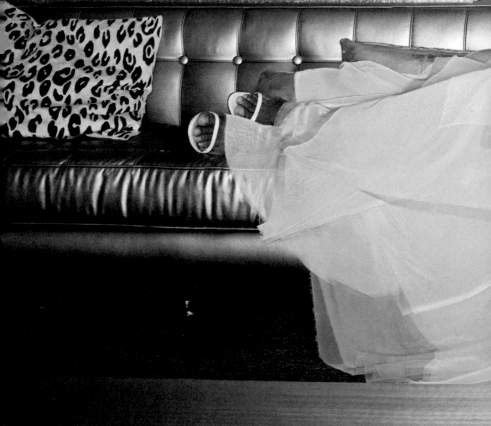

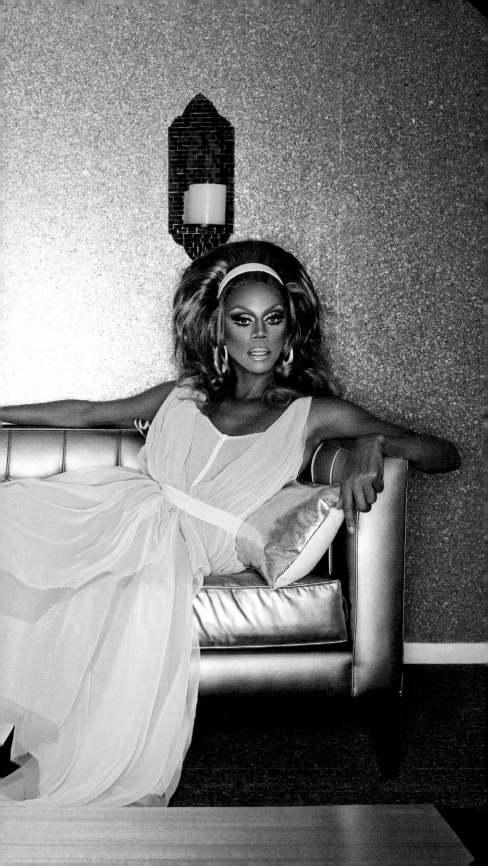

idea to do some experimentation with your foundation and powder using a digital camera with both flash and sunlight.

Brushes are used to apply the foundation, and then sponges to soften the edges for a seamless gradation. My whole face is reshaped and contoured to force the camera's eye to see what Mathu wants it to see, depending on the lighting. The overall concept is to nudge the proportions of my face so that it appears more feminine, softer, and more vulnerable.

Did you know the facial proportions scientifically determined to look "feminine" are the same proportions of a child's face?! We're hardwired to have that "ah" response to both beautiful women and to children. That look is disproportionately large eyes and a heart-shaped face with a wider forehead and a smaller chin—that's what we respond to. Both Marilyn Monroe and Rita Hayworth had electrolysis at their hairlines to achieve this facial proportion.

With our foundation and contouring in place, we powder and set it. This amount of foundation must be set well. We use lighter-colored powder on the highlighted areas and darker-colored powder for the contoured areas.

Now my face is ready for eye shadow, blush, lashes, and lips!

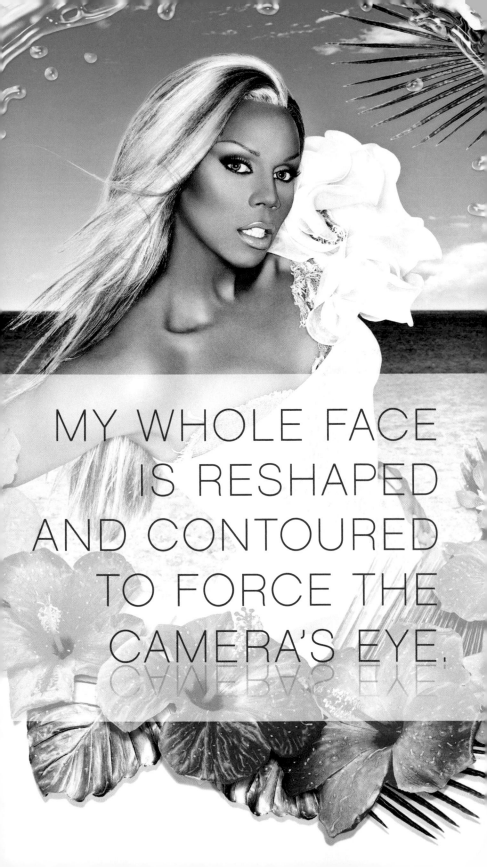

EYES

The general rule is when playing up the eyes, keep the lips neutral. And vice versa: when showcasing a juicy, puckered lip, simplify the eyes. It's a cliché for a reason—it works. The freedom of drag allows me to break the rules and have both at once. If I want to have an important mouth and outrageous eyes, then so be it. Mathu prefers to avoid shine or shimmer on the brow bone, an aesthetic he picked up while working with Thierry Mugler. By keeping the brow bone consistent with the matte foundation, Mathu keeps my face from looking like a mask. Shaving my natural eyebrows gives me way more eyelid for shadow.

CHEEKS

We just add a glaze of color to the cheekbone to warm it up. We also put a little bit of shimmer highlight dust on the peak for drama. The earlier foundation contouring does most of the work. People generally need less blush than they think they do.

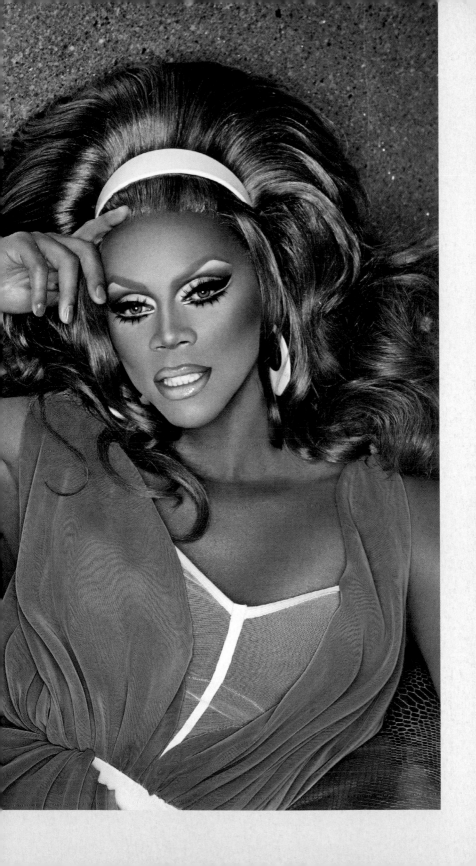

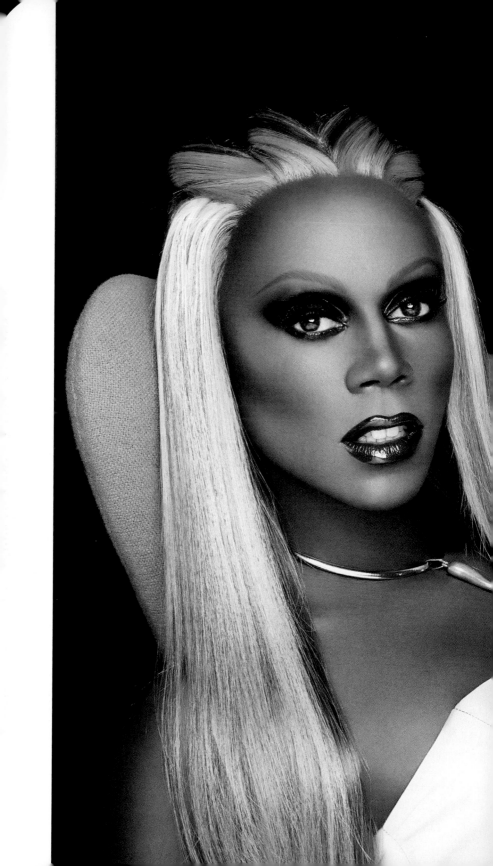

KICKIN' BACK, RELAXIN',
AND LOOKIN' GOOD.

LIP SERVICE

My lips are overdrawn to compensate for my crooked mouth. When I grin, I tend to lose my top lip. So Mathu overdraws the top lip so it can be seen on camera. We use a cocoa brown lip liner. It's my version of a nude mouth, but on other people it would be very strong. And it's a gradational lip: it goes from dark on the outside to lighter on the inside. Like most makeup, it looks best with a good key light.

TWENTY LASHES WITH A WHIP

Before Mathu starts on my false eyelashes, I curl my natural lashes with an eyelash curler, followed by black mascara to the top and bottom. Mathu then chooses a pair of black false eyelash strips that will best compliment the overall look I'll be pumping. Each strip is then cut evenly into four pieces. A very small button-size dab of eyelash glue is then squirted onto the plastic case the lashes came in. Using an old pair of tweezers, he dips the spine of the lash piece into the glue and blows on it until the glue gets sticky. He always starts with the longest piece first, which is applied to the root of my real lash at the outer corner of my right eyelid. He repeats the same steps on my left eye, and then back to my right eye to apply the next longest lash piece. Alternating between each eye helps to maintain a symmetric balance. Gradually, from longest to shortest, he applies all of the four cut pieces to the root of my real lashes. This procedure is repeated with an extra pair of lash pieces if he wants to stack lashes for even more volume. The same technique is used to apply lower lashes. It's important to correctly position the outer lash pieces so as not to let them dry droopy. If the curvature of the lash droops below the outer corner of your eye, gently push it up for the coveted cat-eye angle.

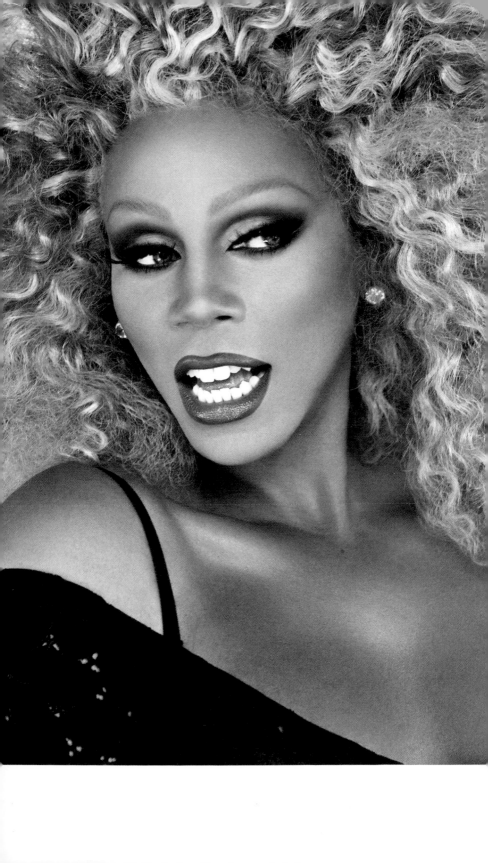

I top it off with *a little*

HOPE CHEST

Creating the illusion of a sumptuous-looking bosom is simple using the shadows-and-light technique. Once my push-up bra and gym socks (wink-wink) are in place, I take a makeup brush and dip it into the same gold shimmer highlight dust I've used on my cheekbones and shoulders. Then I very lightly draw what looks like a martini glass onto my chest—the stem of the martini glass being between my breasts. For pale skin, use a white shimmer highlight dust or white foundation. Remember to start with a small amount of shimmer highlight dust and blend.

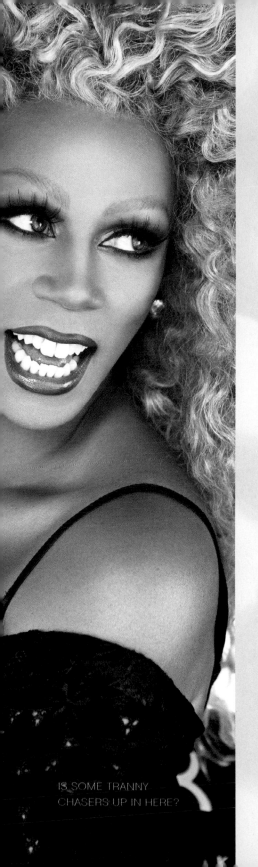

shimmer

BODY-TO-BODY MAKEUP

I use liquid body makeup on my arms and chest area to keep my exposed skin color consistent with my face. Then I top it off with a little shimmer highlight dust on my shoulders and clavicle to add some magic. Civilians don't need to use body makeup unless they expect to be photographed with a flash camera. Mixing liquid body makeup with lotion or moisturizer is a terrific way to keep it looking more natural. And yes, the body makeup does rub off onto clothes, so be very conscious of what comes into contact with your made-up areas.

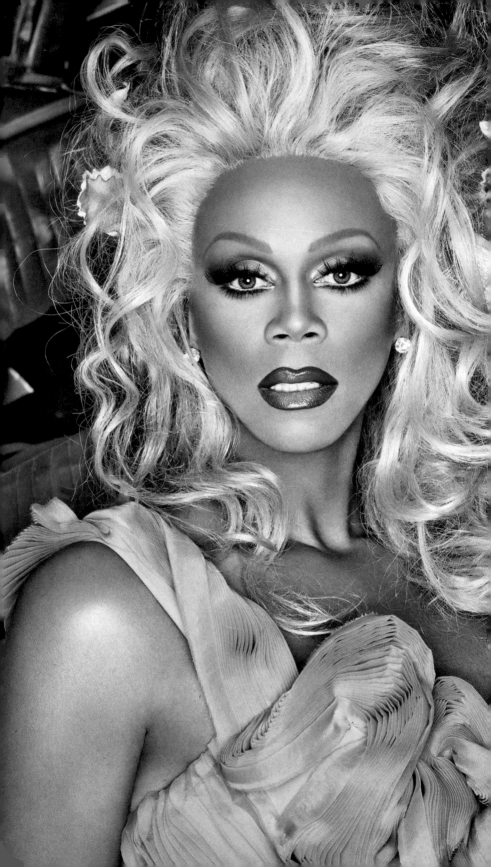

Love is
in the
hair

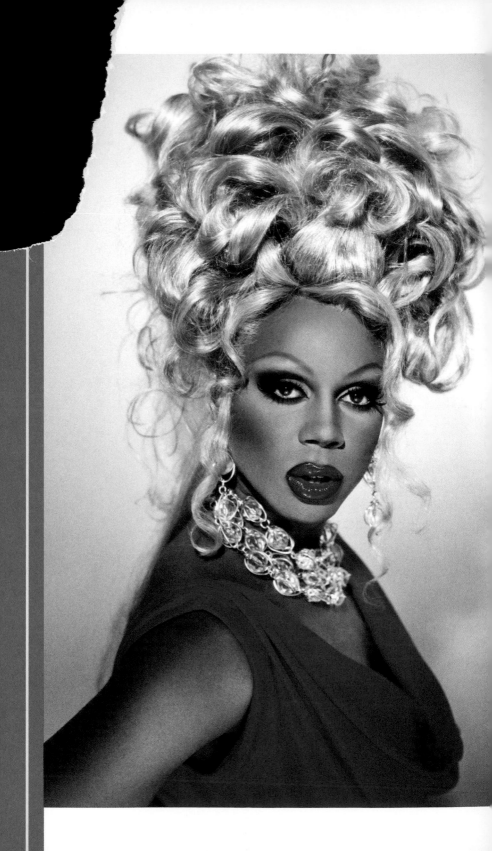

MY HAIRSTORY

y first wig was given to me by Clare Parker of the rock band Now Explosion. She actually gave me two wigs that I piled on top of my head to make one big mass of hair. I needed the wigs for a movie I was starring in called *Trilogy of Terror,* a student film spoof of the old Karen Black classic. I was mesmerized by those hairy marvels of modern man. To me, the whole concept of being able to instantly transform your identity with a mop of synthetic hair represented the totality of advancements made in the industrial age: a cheap, non-biodegradable tool of vanity. It made me feel proud to be an American.

Wigstock, the legendary Greenwich Village outdoor festival chronicled in the namesake film, is remembered as a celebration of drag queens, but it really started out as a nonconformist statement about the superficiality of our consumer society, symbolized perfectly by the synthetic wig. It was a time when kitsch, thrift-store clothes, and yuppie bashing was de rigueur in the art-school dropout scene.

My drag look back then was "gender f@&k"—more of a social statement than female impersonation. Smeared lipstick, tattered prom dress, and combat boots. The whole look was topped off by a discarded symbol of postwar affluence: the synthetic wig. The look suited the anti-Reagan sensibility of the time and gave me satirical edginess as lead singer of the rock band Wee Wee Pole.

During the latter part of the eighties, I transformed my look to accommodate a change in the nightclub business. To make money from hosting parties and go-go dancing gigs, I became a sexy drag queen. Up till then, my repertoire of looks consisted of "funky downtown bohemian" and "gender f@&k." I knew I had "the hotness" in me because people told me in no uncertain terms that even in my raggedy drag I

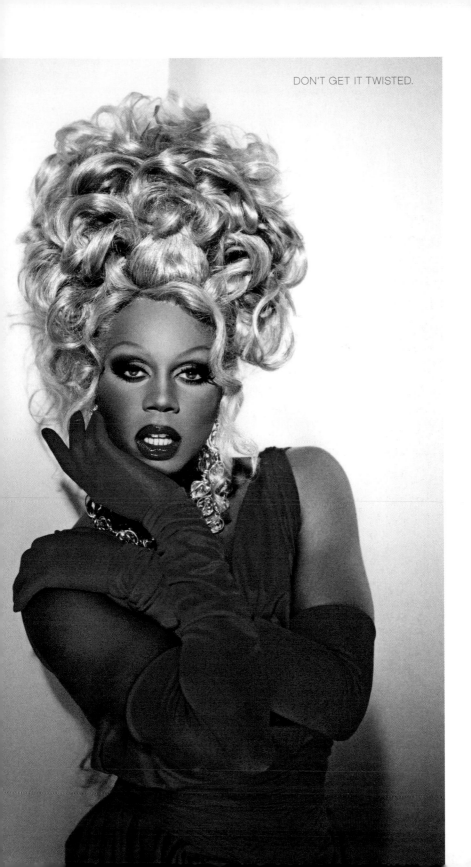

DON'T GET IT TWISTED.

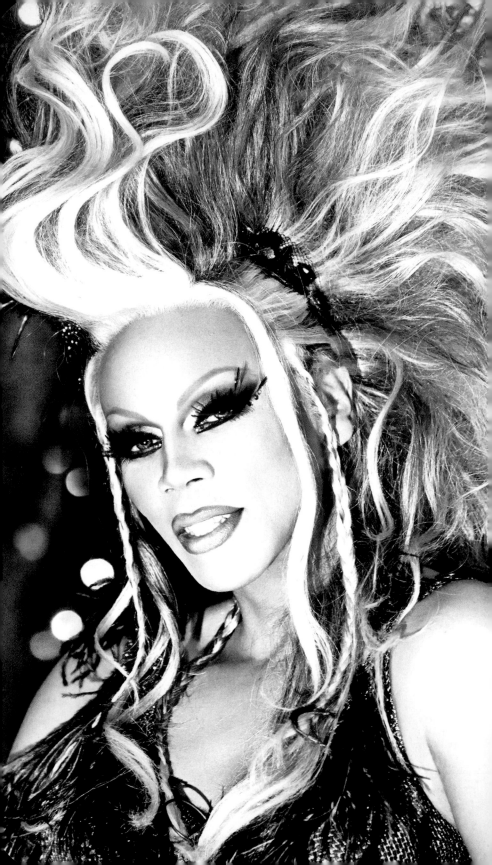

Proportion is
everything

looked glamorous. My interpretation of sexy drag
was inspired by the eighties pop girl groups
Vanity 6 and the Mary Jane Girls. I called my new
incarnation "black hooker." I started shaving my
body and stuffed a bra with gym socks. I made
tiny little skirts, tube dresses, armbands, and leg
warmers. I bought Donna Summer–style wigs,
curly or straight, red, black, brown, and blond,
and always long. I'd accessorize them with
headbands, feathers, and fake flowers. It was a
smashing success. My new look made me the
toast of downtown Gotham, and earned me the
crown of Queen of Manhattan.

The decision to become a full-time blonde
came from my desire to create a cartoon
character image that could be easily identified as
a brand. From my collection of pop culture
influences, I added two parts Diana Ross, a pinch
of Bugs Bunny, two heaping spoonfuls of Dolly
Parton, a dash of Joseph Campbell, and three
parts Cher. It worked. I worked. You better work!

I was *mesmerized* by those hairy marvels of modern man

I was introduced to lace-front wigs around the time I was changing my look from underground "black hooker" to mainstream "glamazon." I bought my first from Barry Hendrickson at Bitz-n-Pieces in New York City. Lace-front wigs are custom made to emulate your own hairline. A thin, virtually transparent layer of lace is sewn to a wig and individual hairs are looped through the lace. This gives the illusion of hair growing out of your scalp. The good ones cost anywhere from $800 to $1,500, but you can get non-custom ones much cheaper. The problem with non-custom lace-fronts is that everyone's head proportions and hairline are different—making the degree of "spookability" much higher.

I prefer my lace-front wigs to be synthetic. They're more durable and hold on to the style much longer. Mathu usually uses a full lace-front wig, plus a comparably sized matching piece to add volume on top. No matter how big he makes the hair look on the wig stand, it always looks much smaller on my head. I'm six foot four—hello. And with hair, heels, and attitude . . . I'm through the mother-freakin' roof! Needless to say, proportion is everything.

People always ask me, "How many wigs do you own?" Truth is, I don't really know. Probably one hundred, but the number of "girls"

(as we like to call the wigs) currently in rotation for filming and performances is closer to fifteen. Keep in mind that each girl is actually two wigs, making the count thirty. Some of my girls have been with me, still in rotation, for fifteen or more years. After a girl has served her purpose, she is sent back to Bitz-n-Pieces for cleaning and reconditioning. Then back to Mathu for repurposing. Some girls have twin sisters, but most don't. So if you see a curly girl in these pages that is the same color as a straight girl on other pages, chances are she's the same girl.

STYLING WIGS

I wish I could tell you of the myriad great wig stylists out there, but I can't. Basically it breaks down into two camps: the people who can style human hair wigs and the ones who can style synthetic. Rarely have I met someone who can do both. Synthetic requires steam to get a curl, while human wigs can be set and styled the way you would your own hair. That said, the biggest hurdle in finding the right wig stylist is making sure he or she doesn't turn your girl into a "pageant-do"

or, worse, the "matronly mother-in-law." It's very easy to get stuck with one of those two options. Plus add the fragility of working with lace fronts, and you've got yourself a tight squeeze, but doable. There are great people out there doing wigs (rotsa ruck finding them— ugh!). The best bet is to develop a relationship with a talented salon stylist who has some experience and imagination.

WEARING WIGS

I've never had a wig come flying off unceremoniously, but I came close to it on a music video shoot for the song "Good Stuff" by The B-52s. An overzealous jib camera operator practically scalped and robbed me of my pride, but thanks to heavy-duty lace glue and a securely tightened safety belt, it did not happen. Lately, I've been incorporating toupee tape into my lace-front-wig-adhering bag of tricks—made easier by the fact that I shave my head. Toupee tape is more fail-safe than glue simply because you don't have to calculate drying time.

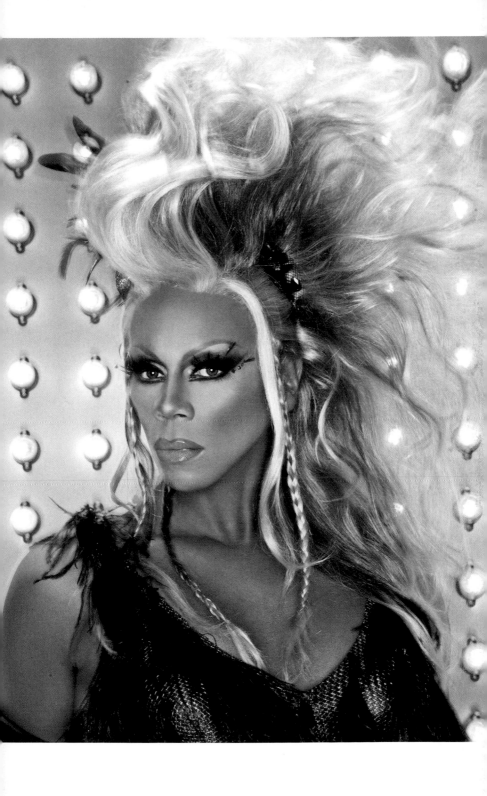

Gluing

1. Before my makeup is applied, I place small strips of clear tape on my widow's peak, temples, and sideburns to provide a clean, dry surface for later when it's time to Spirit glue the lace front to those areas.

2. After makeup is finished and temporary face-lifts are tied, the strips of clear tape are removed, and the lace-front wig is placed on my head.

3. I position the wig hairline on top of my natural hairline, making sure the girl sits symmetrically. With my shaved head, it's crucial that I position the hairline perfectly; if it's too far back I'll look like Queen Elizabeth I, and if it's too far forward I'll resemble Sir Lady She-Wolf.

4. I make sure the sideburns are even, before tying the drawstring safety belts in the back of the wig.

5. Now it's time to glue. With hair clips holding loose hair away from areas that will be glued, I gently peel back the fragile lace that sits on

top of my widow's peak. I then dab the lace glue onto my shaved widow's peak with the brush applicator.

6. A wooden Popsicle stick or plastic knife is used to tap the glued area several times until the glue gets tacky.

7. Once the glue is tacky, the lace is allowed to fall flat back into place, flush with my skin.

8. I take a piece of cut nylon stocking and push the area to further flatten it and make sure the lace adheres to my skin.

9. I repeat the same technique on my sideburns, making sure the lace is flat with no buckling.

LONG HAIR ON MEN

Long hair on men is beautiful, as long as the wearer doesn't have a receding hairline or have it cut into a Hi-Low. Long hair on a man used to mean he was either a hippie, a rocker, or a Chippendale dancer. Now it can be very fashionable if trimmed to the right proportion. I often wonder about the guys I see with really long hair who have it tied back in a ponytail all day. Do they only unleash the wild mane in the privacy of their own garage while playing air guitar? That's no different than the women who are out and about with rollers in their hair. For men who see their long hair as a declaration of their rebel spirit, what's the use if it's tied up all day? Let your hair down! If it's too much to handle during daily activities, keep it long, but trim it to a manageable length.

Toupee Taping the Lace

This is the same concept as the glue, but not as potentially messy. The bottom side of the toupee tape is adhered to hairline areas prior to makeup, while the unexposed top side of the adhesive strip is covered by protective wax paper. After my makeup is done, the lace-front wig is positioned, and the drawstring safety belts are tied, I gently peel back the fragile lace that sits on top of my widow's peak and I peel off the protective wax paper to expose the top side of the toupee tape's adhesive strip. I repeat the same technique on my sideburns, making sure the lace is flat with no buckling. The only drawback is that toupee tape can appear shiny under the lace. Powdering can take some of the shine down.

HUMANOID

As I have mentioned, human hair wigs are lovely, but setting them in a style and keeping that style is a challenge. I use human hair wigs only for down dos, parted in the middle with lots of wavy volume and very little hair spray, so as not to inhibit its movability. Human hair wigs are very sexy when kept as natural as possible.

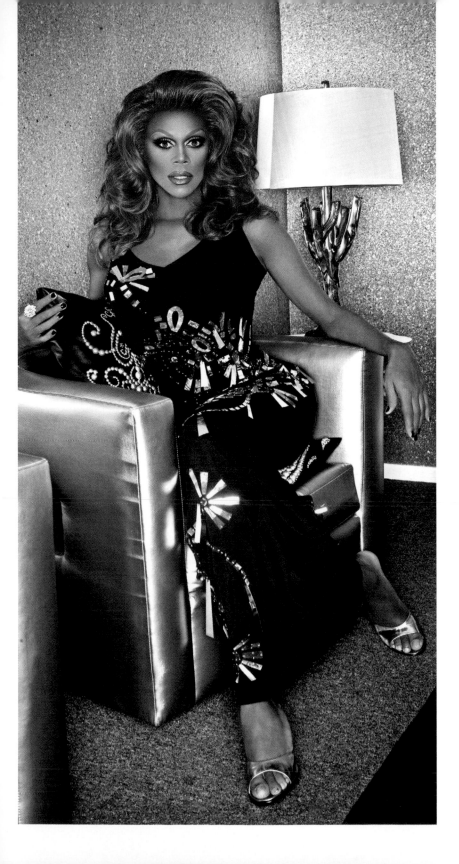

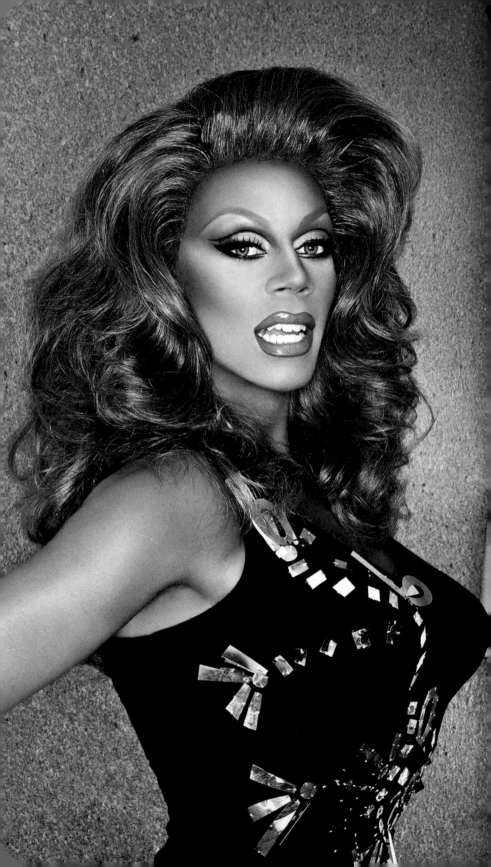

You better *work!*

TRAVELS WITH MY WIG

In the early nineties, Lypsinka told me that Cassandra "Elvira" Peterson had told her that Cher had several kick-drum cases customized to house stationary wig heads for travel. So that's exactly what I did, and I checked the kick-drum case at the airport with my other luggage. It worked fine; those damn cases are huge, but then again, so was my hair. We're talking architectural wigs that mustn't be crushed. These days, I don't travel with that kind of hair anymore. An extra-large shoe box will suffice, along with some fluffing once I reach my destination. Fluffing 101 is as far as I get with a wig. I'm not at all good at hairstyling. So my touring wigs have to be easy-breezy.

HAIR PROPORTIONS

Just as with clothing, hair must fit your body proportions. Very long hair on someone who is short makes them look even shorter. But they could still achieve a long-hair look by wearing shoulder-length hair, which proportionally makes them look taller. On round faces, hair parted on the side is always best—even better is to pin the hair up over the ear closest to the part, which adds dimension to the face. As I mentioned earlier, I always need height in my hairdos to even out the overall focal center of balance on my body. If you study photos spanning Tina Turner's career, you'll recognize the exact moment she figured out the perfect hair proportions for her body, which was right before her early-eighties comeback. Tina's short torso and short neck are out of proportion to her trademark long legs. She shifts the focal center of balance on her body by wearing hair with lots of height. Cher, on the other hand, can wear very long, flat hair because she has a long neck and long torso. Digital photos are the best way of figuring out your proportions.

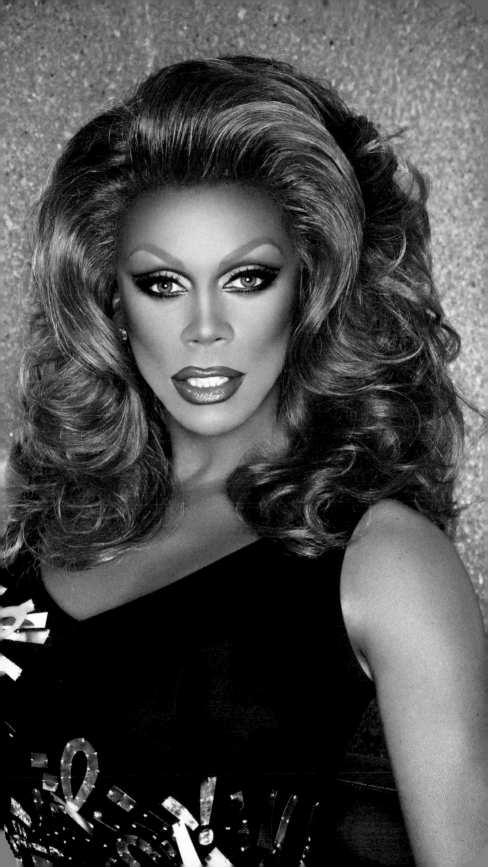

COLOR ME CRAZY

Do blondes have more fun? There's really only one way to find out. Madonna, Pink, and Linda Evangelista are the hair color queens. For such a long time, the story line was brunettes going blond. Lately, the tables are turning, and our favorite blondes (like Scarlett Johansson and Fergie) are going dark. I say do it all, but keep an eye on tone. Some skin tones don't go with certain shades of colors. Everyone can be blond, but everyone can't be the same shade of blond. Warmer blond looks best on my brown skin. I stay away from ash blond.

GOING GRAY

You have two choices: either you embrace it or you color it. If you decide to color your hair, finding the right color for your skin tone is the biggest hurdle. Most people try to reproduce their natural color, but if your natural color was black, you might end up looking like the walking dead. Keep in mind that your skin tone changes as you get older, so adjusting your hair color is a must. Your best bet is to consult a specialist who can be an objective set of eyes for you. Upkeep is a total drag, but you gotta pay the cost to be the boss.

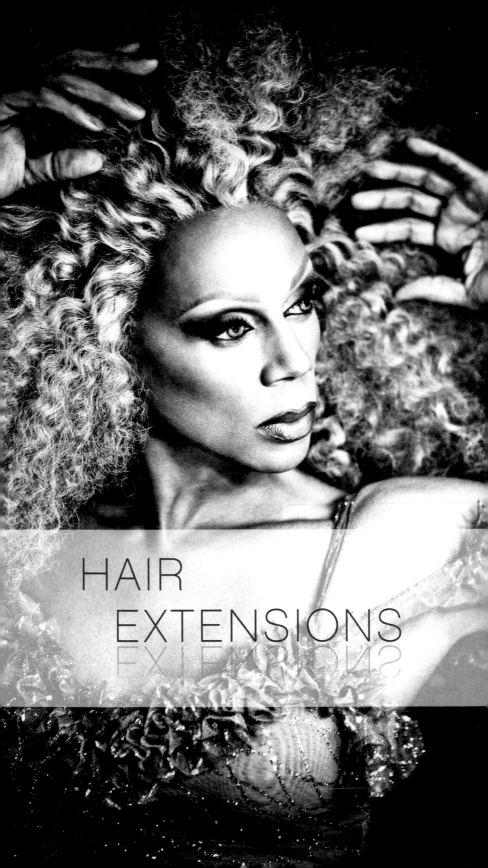

HAIR
EXTENSIONS

I FALL TO PIECES

You used to have to go to a specific wig store to buy pieces and falls—now they're in practically every drugstore. This means people can change their hairstyles whenever they're going to an event or on a date. You can clip on a ponytail or clip in a whole fall very easily. On both seasons of RuPaul's Drag Race, *none of the girls wore one consistent hair look—they changed colors, lengths, and styles all the time. Reinvention is the key to keeping things interesting, and keeping yourself interested. You can change your hair to go with your outfit!*

HAIR EXTENSIONS

Hair extensions are fun, but be careful with volume and length. Proportion is everything! And remember, they are attached to your real hair, so the tension and weight can cause breakage.

PLUCK YOU

During the boy-band craze of the midnineties, it became very popular for straight men to pluck their own eyebrows. They call it "grooming" or "shaping," but to everyone else, it's known as "The Hotness Killer." Mainly because most guys followed their mother's example and plucked themselves beyond recognition, ending up like a cross between Pamela Anderson and Ming the Merciless. I can't tell you how many times I've had to restrain myself from wrestling these men to the ground and confiscating their tweezers. Please, sir, step away from the tweezers. There is a way to clean up

Hell, I even think a unibrow is *sexy*

your brows without making them look "done." Taper the perimeter of the brow with gradation instead of making them look like they've been drawn on. If you are still unsure how to make groomed brows look undone, explain the tapered technique to a facialist and have them do your brows until you get the knack of doing it yourself. Personally, I love a natural brow on a man, unless his brows are crazy bushy like Andy Rooney or Albert Einstein. Hell, I even think a unibrow is sexy.

THE COMB-OVER THE MOON WATCH

Straight up, it does not work. By combing the remaining hair you have to disguise or cover the hair you've lost only makes you look desperate and delusional. No one has said anything to you because no one wants to hurt your feelings. Trust me, you look much better without the comb-over. Have your hair clipped short or shave your head altogether. You will look much sexier.

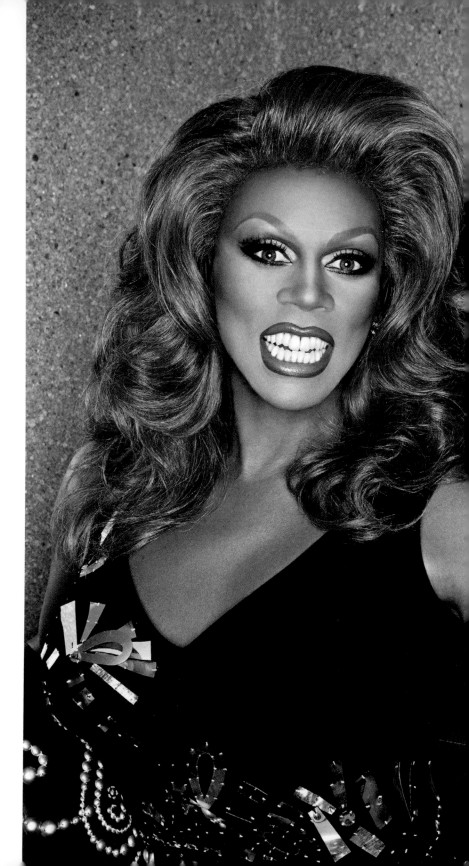

Reinvention
is the key

BANG BANGS

This is another example of where knowing your proportions really comes in handy. Depending on the shape of your face, bangs can totally rock. But if your face is round and your neck isn't very long, you might resemble someone from Middle Earth if you do a straight-across bang. In that case, people with round faces should try a side-part bang as an alternative, with a cheekbone and ear (on the same side) showing. It will give dimension to the face, while still technically being a bang. If your face proportion can handle a bang, but you don't want to commit to cutting your hair for bangs, try the clip-on variety. They're fabulous! With your hair snatched back in a ponytail, or just worn down, you simply clip it on and go bang a gong.

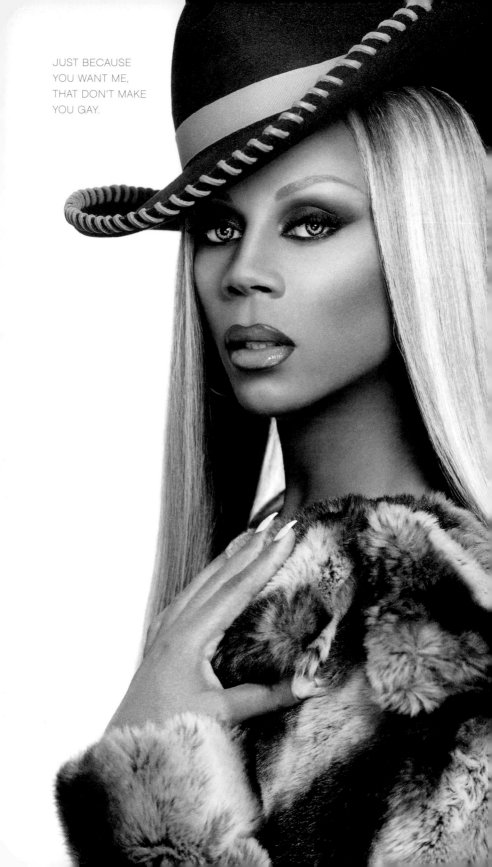

JUST BECAUSE
YOU WANT ME,
THAT DON'T MAKE
YOU GAY.

The
wardrobe
department

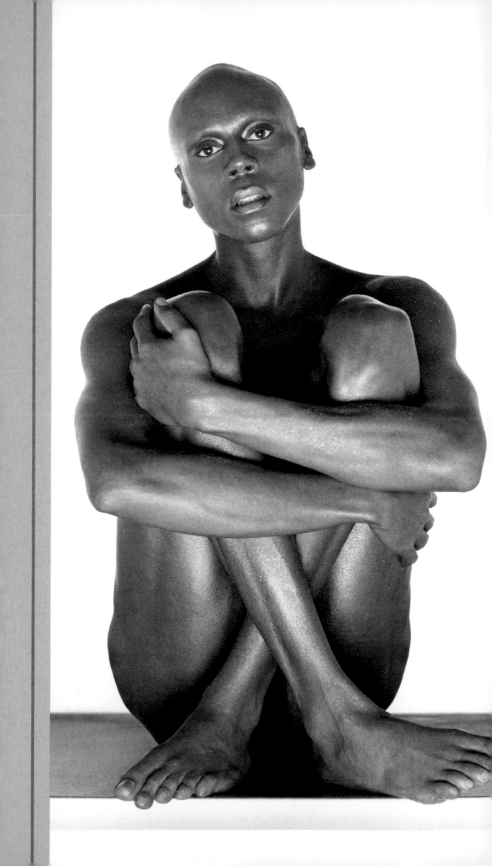

HINDSIGHT 20/20

When an airplane takes off and flies into the horizon, it looks as if it's getting smaller and smaller. But is it actually getting smaller and smaller? No, it's not. It just looks that way from where you're standing. Depending on your perspective, or where you're standing, your perception can be skewed.

This has never been truer than when you see an old photo of yourself wearing some hideous "ouch-fit" and say to yourself, "What was I thinking? And why didn't someone tell me how awful I looked?" Now ask yourself what it would have taken to get you to see then what you see now. Is there anybody currently in your life that you can trust enough to give it to you straight? It's kind of

a tall order for friends because they may have an agenda or they just don't want to hurt your feelings. Your best bet is to educate yourself by getting to know what works on your body, much the same way a dedicated musician eventually gets to play Carnegie Hall: practice, practice, practice! If you're serious about looking the best you can, assuming your body is in pretty good shape, you must do your homework.

Start by getting inspiration from the classic fashion houses: Yves Saint Laurent, Christian Dior, Givenchy, Valentino, and Chanel. Go online to Style.com and spook their current collections to see how shapes and colors are paired. Some combinations will speak to you immediately and others will leave you cold, which is perfectly fine. Then branch off into some of the more adventurous designers: Jean-Paul Gaultier, Alexander McQueen, John Galliano, Etro, and Vivienne Westwood. Remember, wardrobe is first and foremost there to complement the frequency you have worked so hard to clear a path for. Search for ideas that could enhance your frequency. You won't become an expert overnight, but after a few months, your own aesthetic will emerge.

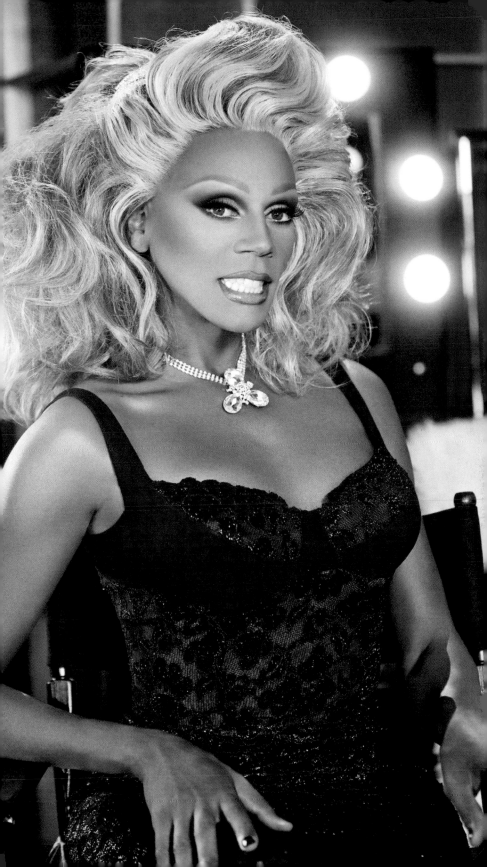

INVENTORY

Now it's time to edit your existing wardrobe. The
rule is if you haven't worn it in a year, get rid of it.
Trash it or give it away. By doing so, you leave
room for more to come into your life. Be a
participant in the energetic flow. Hoarding stuff
blocks energy and makes you stagnant. This is
more than just symbolic. It's an approach to life
that will keep you vibrant and fresh with new
ideas. I've never had a problem getting rid of old
stuff, because I wear the hell out of everything I
own. I change clothes at least three times a day.
It's the only way I can justify all the shopping I
do. Prada to the grocery store? Yes! Gucci to the
dry cleaner's? Why not? Dolce & Gabbana to the
corner deli? I insist!

A basic wardrobe is made up of just a few
classic pieces. Of course, those pieces slightly
vary between men and women, but the philosophy
is still the same: quality clothing that fits well.

You must
do your
homework

Once you have the basics, you can build on the primary theme and add accessories to accent your personal style. Remember to never balk at spending the big money for the finest shoes, bags, and belts. That way you can accessorize an inexpensive pair of jeans and a plain white T-shirt to look like a million bucks. Having a talented tailor is also key to every sharp dresser. Ask your well-dressed friends or well-dressed people you run into on the street if they can recommend an awesome tailor. The good ones are expensive, but they could make the difference between an okay-looking outfit and a rockin' showstopper!

Once you've narrowed down your existing wardrobe to the pieces that really work for you, get out your digital camera and do an experimental fitting. Put different combinations of pants, shirts, scarves, and belts together. Photograph each combination, using the timer on the digital camera. Talk about having another set of eyes! It will be very clear to you what works and what doesn't. Plus, it'll save you valuable time the next day you don't know what to wear. All you'll have to do is look at your collection of digital photographs and decide.

PROPORTIONS

Ever wonder why store mannequins always look fantastic, even in rotten clothes? The answer is body proportions. Mannequins are built with the body proportions that are balanced and pleasing to the human eye—the same body proportions clothing designers cut patterns for. If you don't have mannequin body proportions, you too can look fantastic in clothes if you learn how to choose clothes that direct the focus of the human eye. The human eye is looking for balance and symmetry. Until you fully understand this concept, it's best to enlist the help of your trusted digital camera to give you an undistorted view of your body proportions. Photographs will show if your legs, neck, and torso are long or short. They'll reveal broad shoulders, narrow hips, barrel chests, and knocked knees. Don't be afraid to find out what you're really working with. Identifying your weak areas is the first step to showcasing your strong areas.

I have very long legs and a comparably short torso and neck. To balance my silhouette in drag, I always wear hair that has a lot of height (even when I'm wearing it down) and I keep the area

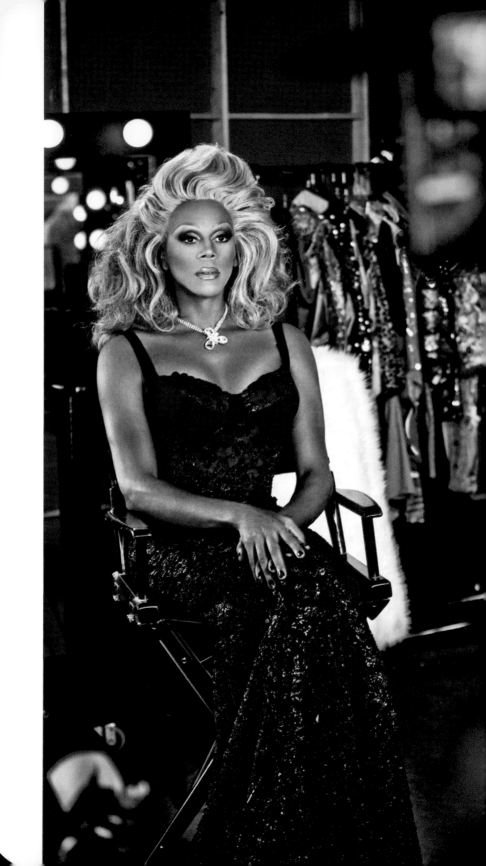

between my chin and breast bone clear of obstruction. No scarves or turtlenecks, and rarely do I wear necklaces. For me, an open-V neckline elongates the whole upper portion of my body. That way, it forces the eye to see my center of balance as lower than it actually is. The one exception to my rule is if I'm being photographed from only the waist up.

Out of drag, I can wear turtlenecks, fitted T-shirts, and scarves because my center of balance is already lower from wearing flat shoes. But even then, I will throw on a hat with a tall crown or wear monochromatic colors to balance my proportions. Most men's jean jackets are cropped much lower than where my waist falls— so that would make me look sloppy. A big optical no-no for men is a tucked-in shirt with short sleeves that are too long. Short sleeves must stop at least four inches above the elbow. If not, it makes the waist look abnormally short and disproportionate.

If your legs are short and your torso is long, bring the focus higher. Narrow shoulders need padding to compensate. This process of shifting the focus is made much easier with the keen eye of a terrific tailor. Make it your mission to find one.

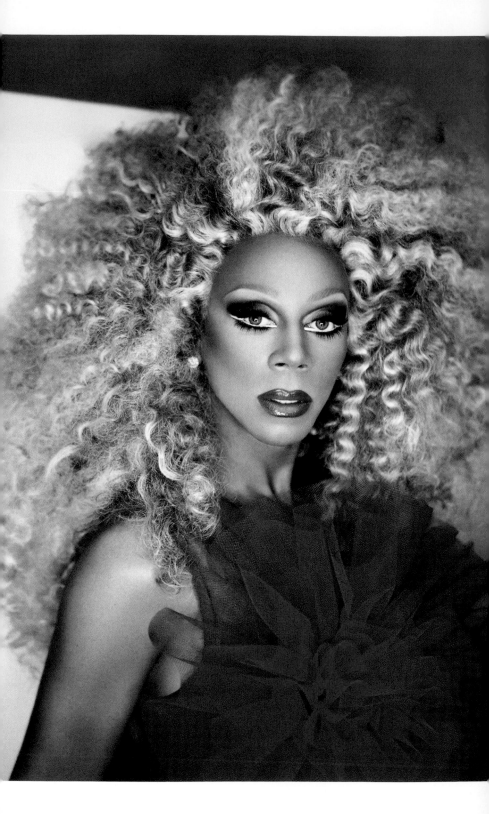

Fashionistas
can make
anything work

ACCESSORIES

Call me old-fashioned, but generally I like to match the color of my shoes with my belt and bag. Obviously, there are exceptions. I've seen some really boss fashionistas make multicolored accessories work, but the general public not so much. I have the same philosophy when it comes to jewelry: gold with gold and silver with silver. Copper I will mix with gold. Again, the boss fashionistas can make anything work.

THE BASICS FOR MEN

a fitted blue suit

a pair of dark blue jeans

a white button-down shirt

a black button-down shirt

a skinny black tie

a black cashmere V-neck pullover

a red cashmere V-neck pullover

plain white T-shirts

a striped French sailor shirt

a fitted khaki trench coat

a blue peacoat

THE BASICS FOR WOMEN

a fitted blue suit

a simple black dress

a black knee-length pencil skirt

a pair of blue jeans

a white button-down shirt

a black button-down shirt

a black wool button-down
V-neck sweater

a camel cashmere button-down
V-neck sweater

a black wool turtleneck sweater

a striped French sailor shirt

a fitted khaki trench coat

a fitted black knee-length peacoat

SPIT YOUR GUM OUT,
GIRL! YOU'RE ON!

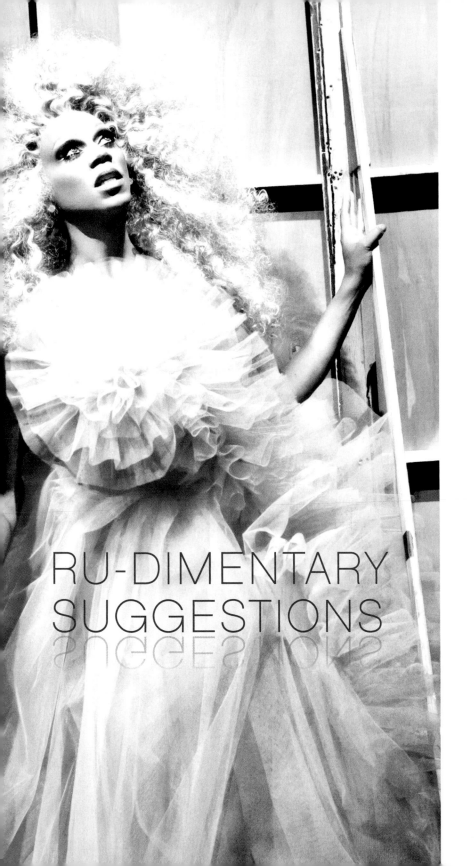

RU-DIMENTARY
SUGGESTIONS

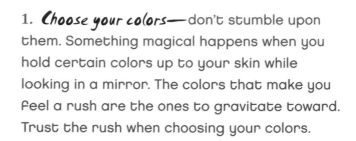

1. ***Choose your colors***—don't stumble upon them. Something magical happens when you hold certain colors up to your skin while looking in a mirror. The colors that make you feel a rush are the ones to gravitate toward. Trust the rush when choosing your colors.

2. Know your feet. Get to know the various shoe brands. Some are not built for your foot shape. If you're not comfortable, you're not going to look good or walk well.

3. ***When you put it on*** and it feels wrong— it is. Take it off.

4. If you're dressing to please other people, you've lost yourself. Plus, other people are too self-absorbed to notice or care. I find the only people who notice I'm wearing something chic are the ones who work in boutiques.

5. ***When wearing all white,*** always wear a black bra and panties.

6. If you must buy a trendy item, buy the inexpensive knockoff. It's not worth paying

big bucks on a trend that will be over tomorrow.

7. **Everyone needs The Gay** in their life. Someone who says, "Kiddo, this look is not the one!" But don't get it twisted! Gay men were not put on this earth just to serve as your personal stylist. We have our own wants and needs that have to be met on a human level. Friendship is a two-way street.

8. "Scrunch boots" make legs look short. Do not wear boots that shorten your legs.

9. **Embrace the gift** of height. Don't avoid heels to make your date feel taller. It won't work. Your height is not the problem; his ego is. Egos are in the business of being fragile.

10. Don't ever take your heels off in public and walk around barefoot while carrying them. Quite frankly, it makes you look trashy. If you plan on being in heels for a long time, say at a wedding or an event, wear mules. They're much more comfortable than closed-toe stilettos or strappy sandals.

NEVER EVER?

1. Never wear workout shoes or gym apparel outside the gym.

2. Never wear a T-shirt that advertises a business or a past event.

3. Never wear more than one designer logo at once.

4. Never wear pleated pants unless your stomach is flat.

5. Never buy something you haven't tried on first.

6. Never wear a fanny pack.

7. Never wear pants that stop midcalf.

8. Never wear an oversize T-shirt to try to cover your big butt. It only makes it look bigger.

9. Never wear hair rollers or a do-rag in public.

10. Never wear stacked marshmallow flip-flops.

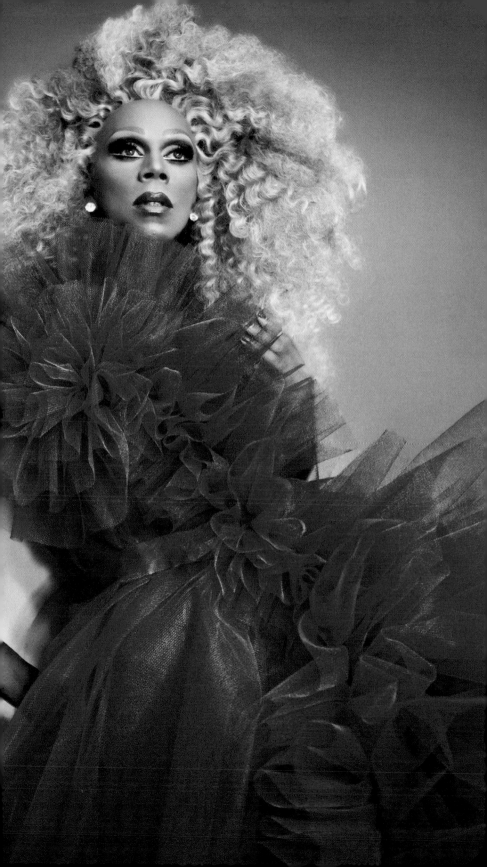

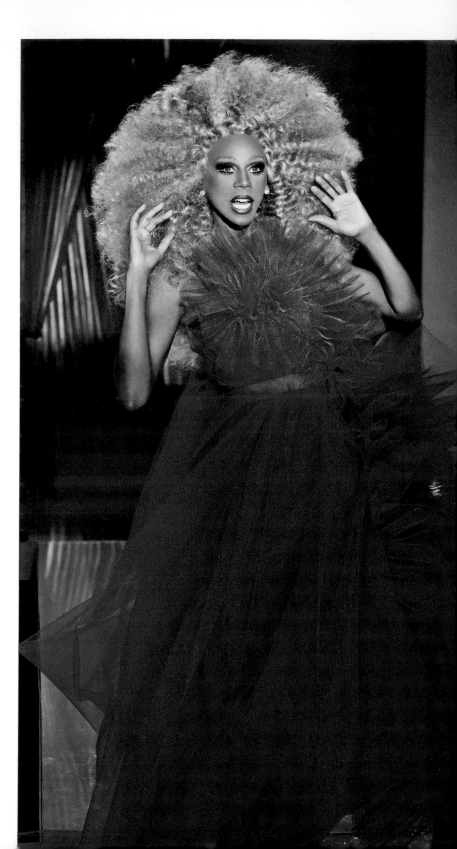

FIRST TIME IN DRAG?

I wish there was a crash course in glamazon, but there isn't. It just takes practice, practice, practice! Take pictures of yourself and learn from them. Also, be willing to make mistakes (and trust me, there will be some), but don't beat yourself up over them—have fun! It is truly a matter of celebrating life with a sense of humor and savoir faire.

Here are a few tips for drag queens just starting out:

Choose a *name*

that flows and rolls off the tongue—
something clever, but not too complicated.

Never wear your own hair.

If you have a nice hairline (one that is not receding),
you can feature a hairpiece or a fall.

Always feature

Never wear men's attire while in drag,

for example, your daytime glasses, an overcoat,
slacks (unless you are padded), sneakers, or flat
shoes.

Always serve a

full-coverage foundation with powder.

Never let *anyone* see you eating food while in drag.

Never respond to someone who yells "Hey, slim!" out of a passing car.

Never *lip-synch* slow ballads unless you have at least three years of "showgirl" experience.

false eyelashes.

Shave your eyebrows off completely and paint them on the way God intended! (Otherwise, see my eyebrow coverage instructions in "The Ru Routine" in chapter 3.)

Most important, **be kind.**

There are enough "bitchy queens."

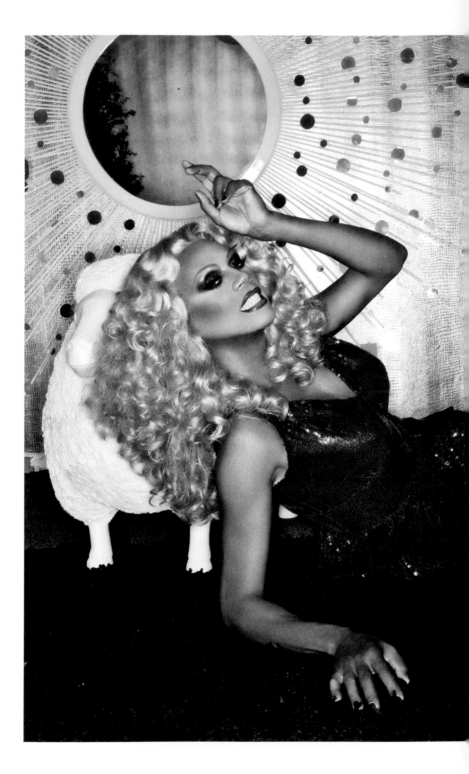

LIFE'S LESSONS ARE LEARNED
THROUGH MISTAKES. DON'T BE
AFRAID TO MAKE THEM.

GOOD GIRL GONE BAD

Whether you're a nurse or a soccer mom, you can still add a degree of naughty to your nice. If you follow fashion, you'll recognize that a constant theme is the soft brushing up against the rough, the feminine courting the masculine. If you always wear flats, indulge in a pair of high heels and a very tight skirt. Everyone should own a black smudge eye pencil. Break the monotony. Surprise that special someone with your alter ego. Show up one night in a black China doll wig, red lipstick, and high heels. Nothing is more of a turn-on than the unexpected. If you have to wear conservative clothes for work, go the black-lace lingerie route underneath. You'll be tickled throughout the day knowing that you're sitting on a secret. Conservative men can apply this same concept with a black motorcycle jacket, black boots, a white T-shirt, and a pair of Levi's 501s. Throw on a pair of aviator sunglasses and instantly transform into James Dean.

DAY FOR NIGHT

Assuming you don't have a change of clothes in your bag or in the trunk of your car, the easiest way to turn a day look into evening allure is with a few key elements: makeup, accessories, and high heels. Nothing says glamour more than a pair of well-applied false eyelashes (easy instructions in chapter 3). Hair worn down during the day becomes practically magic at night by styling an updo and adding drop earrings. Put lip gloss on your daytime matte lipstick and dazzle them with your smile. Add a touch of iridescent shimmer to your eyelids or cheekbones to catch the light. Use jewelry to spice up a pair of slacks and a blazer—broaches, pearls, and chains add sparkle!

MISS LADY BIGFOOT

In men's shoes I wear a size 12, which means I'd have to find a pair of size 14 women's shoes to walk that particular walk. Trouble is it's very rare to find sexy women's shoes in a size 14*. The best option is to find a pair of slip-on mules in

*Find sexy larger sizes at Enrica Lossi (53 West 8th Street, New York, NY, 10011), or allsexyshoes.com

Confidence.
If you believe it, then we can
see it!

a size 12 or 13. That way, there isn't too much of a foot overhang, and it'll be way more comfortable than closed-toe stilettos or strappy sandals.

WORKING WALKING

In heels, I walk on the base of my foot, putting very little weight on my heels. I use the heel for balance while standing. When people are having problems walking in high heels, it's because they're distributing too much weight on the heel of the shoe. Keep in mind that the fiercest runway savages focus on what's between their ears and not what's on their feet. Confidence. If you believe it, then we can see it!

BAGGAGE CLAIM

I packed a bag and left my mother's
house when I was fifteen. The funny thing
is I have yet to unpack. I've basically been
traveling ever since. In all these years,
the one prevailing rule is don't overpack.
I've got it down to a science. I know it's
better to wear the same thing over and
over than to not wear something you've
packed and didn't even need—not to
mention carried with you to the far ends of
the Earth and back. Aside from essential
clothing items needed for jetting around
the globe, here is a list of nonclothing
items that are always in my luggage.

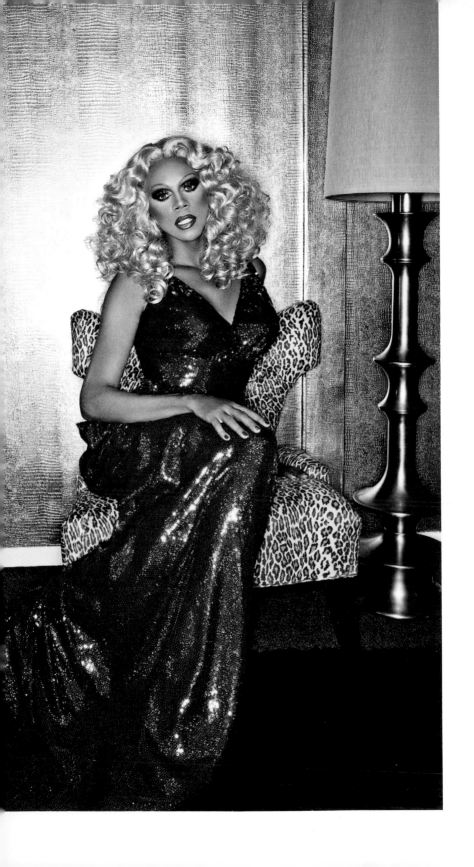

Toiletries

baby wipes
(No explanation needed.)

ibuprofen and
sleeping pills

allergy medication

packets of Theraflu

emery board

nail clippers

tweezers

condoms and lube

dental floss

small scissors

face towel
(Some European hotels
don't have them.)

Electrical

100-watt halogen lightbulb

(Place in empty baby wipes box, wrapped in tissue paper.)

painter's clip-on light fixture

(Remove reflective funnel.)

NOTE: Hotels are notorious for having bad bathroom lighting. This makes it difficult to create an illusion on your face when there are two 40-watt bulbs on either side of the mirror. I wish you could see some of the jerry-rigged lighting I've concocted in hotel bathrooms all over the world, from here to Booragoon.

voltage converter/transformer with adapters

(For overseas travel only. Don't rely on adapters alone. The electrical currency must be converted.)

extension cord

power strip

computer with power cord

external hard drive

iPod

iPod/iPhone charger

two pairs of headphones

headphone adapter

(So two can listen at once.)

portable speaker system

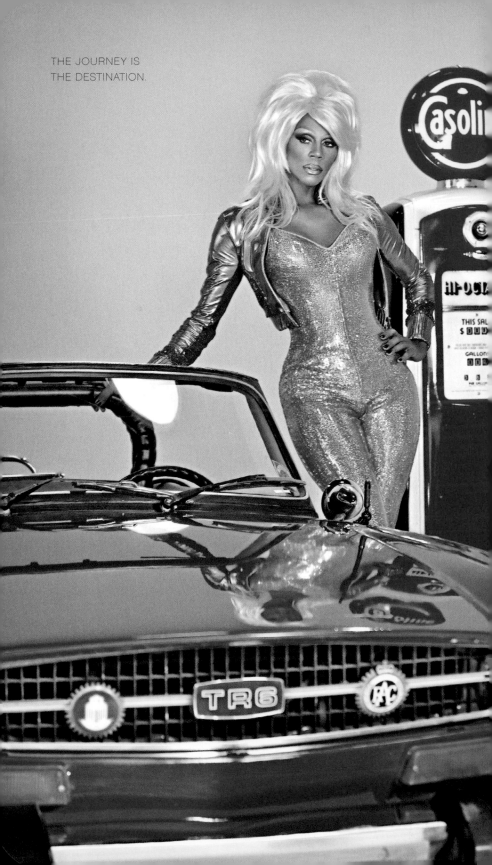

THE JOURNEY IS
THE DESTINATION.

RCA "Y" cord
 (It connects your iPod to a TV
 or stereo via an auxiliary jack.)

auxiliary iPod cord for your rental car

booklet of DVDs, homemade CDs, and
blank recordable CDs

digital voice recorder

digital camera

mini video camera

travel flashlight

portable folding alarm clock

Other

passport or driver's license

sunglasses

reading glasses

paperback book

earplugs

matches

clothespins

safety pins

THE JET SET

The easiest way to consolidate your luggage is to first decide what color accessories you're going to feature on this trip. Brown shoes, belt, and carry-on bag, or black? Gold jewelry or silver?

Then you'll need the following:

a versatile carry-on bag
that can hold a computer

a pair of leather shoes

a belt

a white button-down shirt

a black button-down shirt

a blue fitted Prada
Techno Stretch suit
(pants or skirt)

a pair of black or blue jeans

a slim black tie or scarf

Don't
overpack

a red cashmere V-neck pullover

two plain white T-shirts

undergarments

socks or leggings

black workout top and pants

black swimsuit

black cross-training gym shoes

black flip-flops or ballet slippers

black scull cap

toiletry/makeup bag

Wear your wrinkle-free suit to the airport with a button-down shirt and leather shoes. In cold weather, wear an additional overcoat on the plane. Everything else will fit into one piece of checked luggage. The idea here is to have several clothing combinations that will accommodate every possible occasion without overpacking.

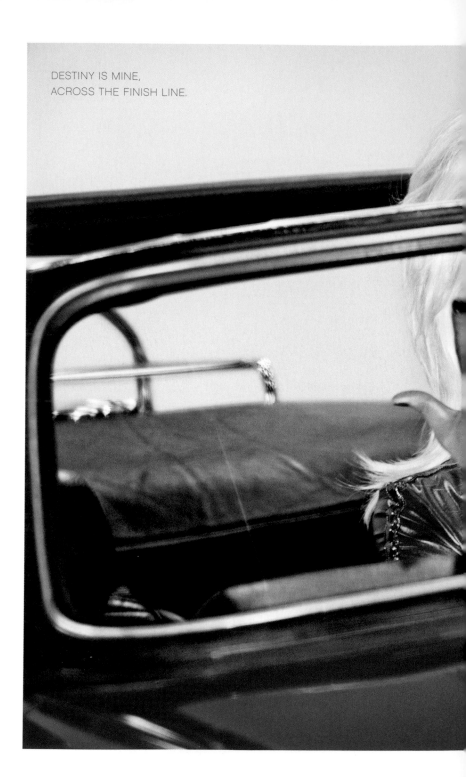

DESTINY IS MINE,
ACROSS THE FINISH LINE.

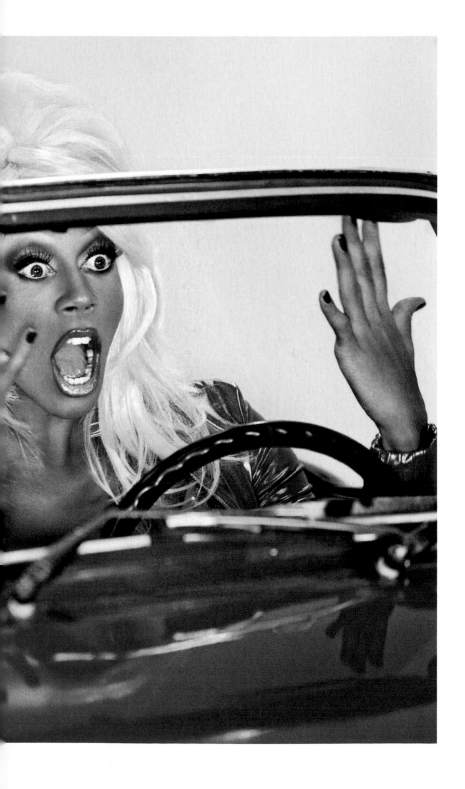

STYLE SUPERSTARS

I think it's important to choose the men and
women whose style speaks to you. Emulate
and learn from them. There's a reason Cary
Grant, Audrey Hepburn, and Jacqueline Kennedy
are enduring fashion icons—they knew who they
were and dressed the part. And their many
incarnations were all slight variations on The
Look that became their image and identity.
These are the icons I have an affinity with—
they've all helped me to define my own style.

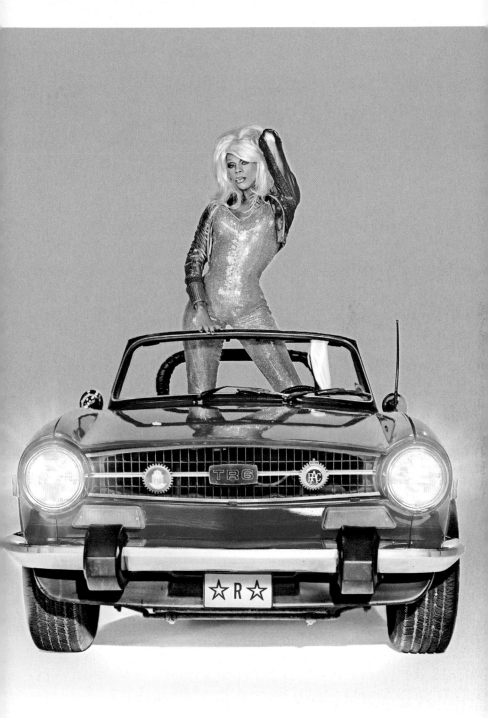

MALE FASHION ICONS

Tom Ford: That SOB is so effin beautiful and elegant! He has clearly dedicated his life to beauty and style.

Cary Grant: TP, baby! The total package. The voice, the confidence, the silhouette. Everything he wore sang his praises.

Isaac Mizrahi: He dresses his body to fit his personality, which I love. Multilayered and textured. His style is classic and uniquely him.

John Galliano: Perfection, drama, humor, individuality. A true maverick. My hero.

Dolce & Gabbana: Even in jeans and a white button-down shirt, this dynamic duo look chic 24/7.

FEMALE FASHION ICONS

Ernestine Charles: Every time I get dressed I still hear her voice saying, "Always look your best, no matter what." She taught me that less is more, and more is better. She was a seamstress and taught me to sew, as her mother taught her. My love of clothes and dressing up is one of the many gifts she bestowed upon me. Thank you, Mama.

Victoria Beckham: The fashion authority! The fiercest player in the game. Major style. You betta work!

Nicole Kidman: She has absolutely amazing, impeccable taste. She chooses very wisely.

Sharon Stone: She's very aware of what works and has a really good eye for color. A real movie star.

Dita Von Teese: She knows who she is and dresses the part. Marvelous!

Diahann Carroll: Very chic. Classic American sensibility. A striking silhouette.

Diane Keaton: Fantastic! She's not afraid to transmit her own frequency. One of a kind.

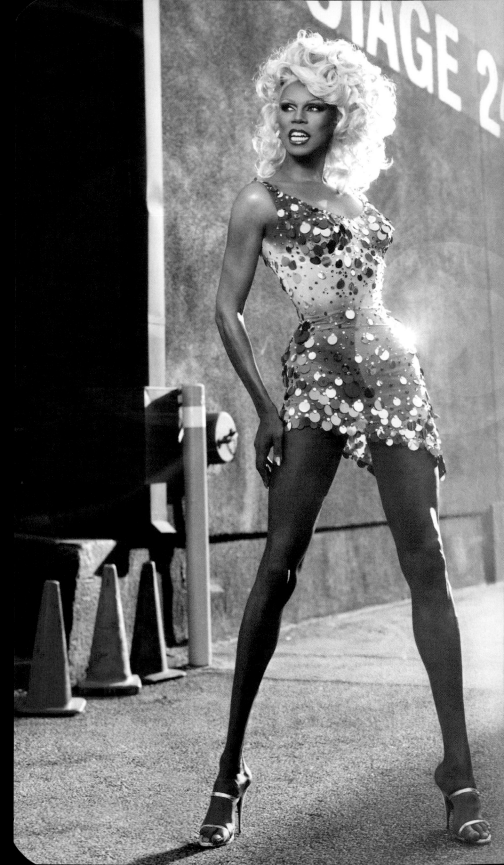

Money, power, and success

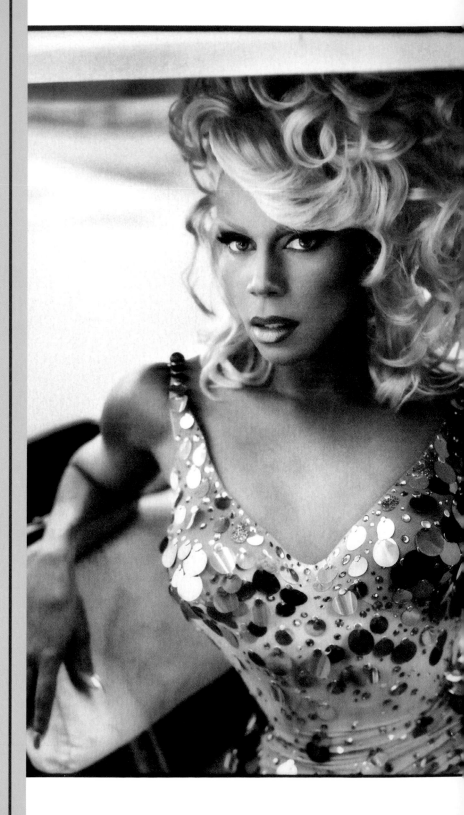

HAVING IT ALL

o you measure success as
defined by your parents, your
friends, or popular media?
Can success still be defined
as "having it all" and "making it big" if deep
down you still feel empty?

As ridiculous as it may sound, I really
believed becoming famous would fill the void—
that emptiness I'd felt in the pit of my stomach
for as long as I could remember. I thought if I
could get the entire world to say, "We love you,
RuPaul!" it would complete me and I'd live
happily ever after. Like Dorothy with her sights
set on the Wizard of Oz, I thought fulfillment
could be found somewhere over the rainbow.

Let me tell you something: I heard the world say my name and I've seen my face on the covers of magazines, and it didn't fulfill me. If anything, becoming famous made me feel more alone and made the void seem deeper, more hollow. What had I missed?

The glaring flaw in the success-equals-happiness principle is that it measures everyone by the same superficial assumption that wholeness can be found in material things. Having money, power, and respect pacifies the ego only temporarily and does nothing to relieve the deeper feeling of emptiness. We're all sold on this idea that wholeness can be bought, married into, or wished real hard for, but the more substantial definition of success requires a lot more than just worldwide recognition and acquiring things. On closer inspection, the void I felt was the spiritual part of me that I had forgotten to acknowledge from the inside out. Shifting my priorities from worrying about what other people think of me to fortifying myself with the truth of who I really am is how I constantly fill that void. The definition of real success includes digging deeper and maintaining fulfillment. Real success is an inside job.

Why is this lesson so hard to apprehend? Do our egos push us toward the thrill-drenched roller-coaster ride of self-doubt, instead of the calmer wave of self-acceptance? Is it possible to teach a fourteen-year-old kid the life lessons that a forty-year-old adult eventually learns on the bumpy ride to self-discovery? I often wonder if the trial-by-fire school of hard knocks is the natural trajectory. Could Dorothy have grasped the power she possessed on an emotional level without having to go all the way

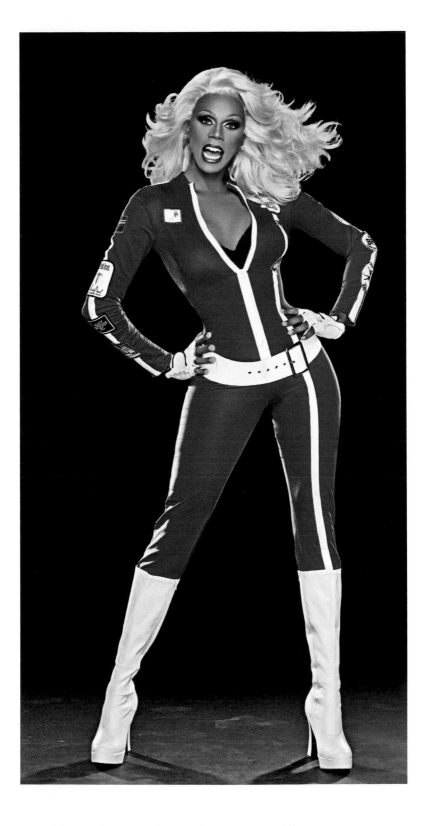

Real success
is an
inside job

to Oz and back? When the Scarecrow asks the Good Witch why she didn't tell Dorothy that she always had the power to click her heels three times to get back home, the Good Witch replies, "Because she wouldn't have believed me." I suppose we all have to earn the knowledge of our power.

Don't get me wrong. I'm proud of my journey through the mean streets of adversity, but I can't help but be a little remorseful over the wasted time I spent paralyzed with insecurity and feelings of inferiority. As a kid, had I been given the processing tools to objectively recognize my Saboteur, I could have circumvented those arduous detours of self-doubt and cripplingly low self-esteem. Developing an objective view of yourself will ensure a personal system of checks and balances that will override The Saboteur.

One helpful technique I use is to look at old pictures of myself and remember the "conflama" (conflict and drama) that was going on when the photo was taken. In hindsight, those issues seem small and inconsequential. Looking back, I can see the many options I had open to me, options I could have acted on had I had the processing tools to work through my debilitating insecurities.

Fast-forward to today, and I apply the same technique. Only now I imagine myself in the future looking back at myself as I am today. I see how smart, beautiful, and fortunate I am, and all the many options I have open to me. I bring that loving perspective into the present moment and seize all those options in the now. This technique gives me an objective view of the moment by overriding the distorted view of my Saboteur. It's like jerry-rigging my consciousness. By adjusting my perspective, I'm able to reparent myself in a positive way. With practice, the time it takes me to catch myself from straying too far off course becomes shorter and shorter. Fulfillment isn't found over the rainbow—it's found in the here and now. Today I define success by the fluidity with which I transcend emotional land mines and choose joy and gratitude instead.

LIFE AFTER OZ

Every seven years, life presents very significant benchmarks. On your twenty-eighth birthday, Saturn returns to the exact same position it was on the day you were born, causing major

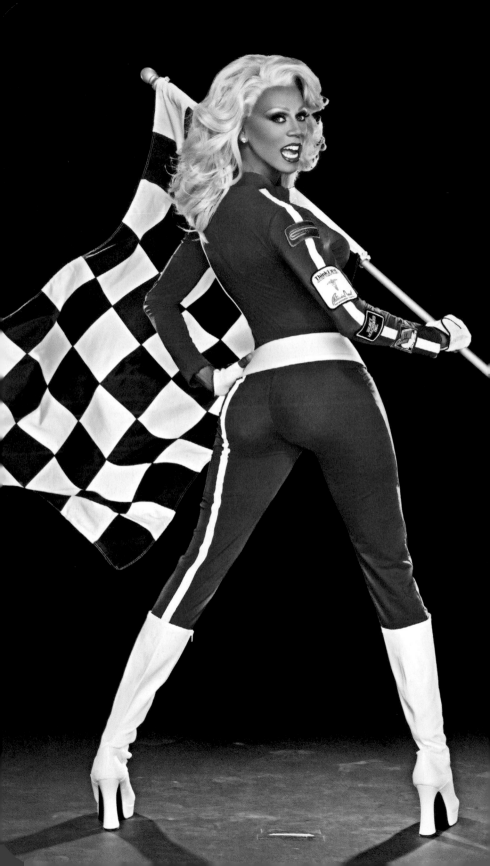

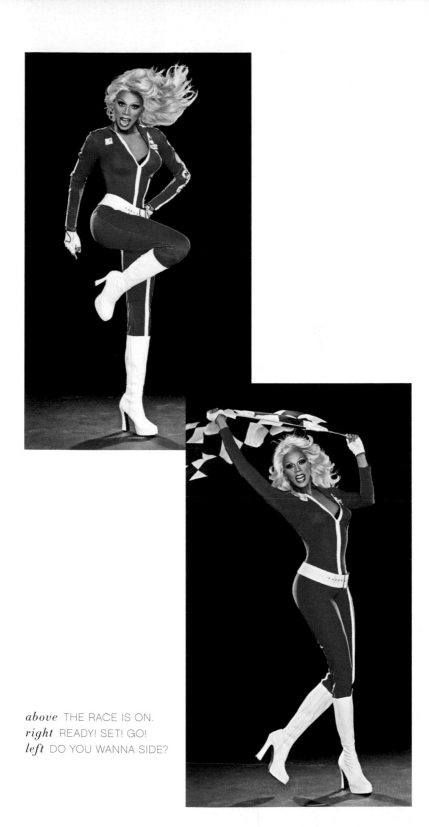

above THE RACE IS ON.
right READY! SET! GO!
left DO YOU WANNA SIDE?

upheaval in your life for the year leading up to its return and sometimes the year after as well. The year leading up to the occurrence runs parallel with Dorothy's odyssey. The tornado, the uprooting of her home, and the drama-filled journey down the yellow brick road are all characteristic of the year leading up to the return of Saturn. The moment Dorothy pulls that curtain back to reveal the truth about the Wizard and the subsequent death of her dream is like the very moment Saturn completes its rotation.

Little is said of what happened to Dorothy after Oz, but my guess is that she went home and rethought her entire belief system. Eventually, she stopped thinking altogether and started using her instinct and intuition. I bet she took some time to regroup and find her true voice—her frequency. I imagine Dorothy doing these things because when my Saturn returned, that's exactly what I had to do. I had some soul-searching to do. I had to sit out a few dances and catch my breath. I had been a local star in Atlanta, an afterthought in Manhattan, and then homeless in Hollywood with no one interested in my career but my eleven-year-old niece.

After licking my wounds, I created new dreams. I planted more seeds. I had begun to understand that my ability to change my perception and reinvent myself was my trump card. I reemerged on the other side of twenty-eight with arms of steel and newfound determination. The darkest night of my soul was over and I felt invincible. Nothing could be worse than what I had already gone through. What's worse than searching for the key to your destiny and not knowing you're already holding it? So I went

I created
new dreams

for it with all my strength. Regardless of winning or losing, I was a success in the truest sense because I had picked myself back up. I was back for more. I had learned to transcend my skewed limitations by changing my perception. Understanding that process on an intellectual level is the beginning. Practicing it on an emotional level is success.

STAGE DIRECTION

Over the past ten years, I've nurtured a consciousness that lovingly guides me on a day-to-day, sometimes minute-by-minute, basis. I recognize this guidance as a kind, loving voice. It suggests that I keep kindness in my heart, that I go to the gym, or even that I order a grilled chicken salad instead of the supersize enchilada combo. It sounds like stage directions from the universe. My part is to clear a signal for that consciousness to come through. Meditating or going on a hike helps to facilitate the communication.

YOU BETTA WORK

Whatever your job may be, do it to the best of your ability. Make it the most important job. I often come into contact with employees at different businesses who have no interest in being helpful or fully committed to their job. It seems they're just biding their time until they get "discovered" or get their "big break." It's as if they feel they're too good for the work. What they don't know is that by being fully committed, their day will breeze by and they'll find pleasure in their job because their spirit showed up. And because they allowed their spirit to enter the building, the spirit of everyone they come into contact with will meet them halfway, creating a flow of energy that creates more energy. The job will no longer be a drain; it will be energizing. The people who grudgingly show up for work are making the work much harder than it is. The work can actually give you energy and create opportunities at the same time. By bringing your spirit into the mix, you'll be creating opportunities for your next job. You never know where that next big idea is coming from. Stay open, because your purpose is standing right in front of you.

You'll be creating new *opportunities*

STAYING INTERESTED

The biggest challenge in my career is staying interested, which I do by diversifying. From the very beginning of my career, I understood that my talent is in being me, and nobody does me better than me. My energy, my unique take on life, is what I bring to the party, whatever the party may be. I know how to be me in front of a camera, onstage in front of thousands, on my morning-drive radio show, or on the pages of this book. So the key to staying interested is putting yourself into many mixes. And yes, there are special technical aspects of every profession, but they can be learned in a relatively short amount of time. The biggest element is the part of *you* that you bring to the table. Know thyself and share it with the world. The day I'm no longer interested is the day I need to walk away and find something that does interest me.

WORKER BEES

It is said that in the workplace, women would rather be liked than be revered. That may be true in a general sense, but is it possible to have it both ways? We've all seen movies where the mean bosses are tyrants and get what they want without any serious repercussions. It seems that people in our fear-based society respond to and respect fear as a motivator. I personally don't react well to tyrants. Life is too short, and nothing is that important or serious. Whenever I've been in charge of a team or employees, I keep the boundaries firmly in place while maintaining a comfortable, nonstressed atmosphere. I don't do tension and stress. I like to think I manage with a soft glove, but when the obvious needs to be said, I'll say it. They say you can catch more bees with honey, but who needs bees? Bees are annoying and sting. Just give me the honey and I'll give you a sweet bonus come Christmas.

AUTHENTICITY

If you say you're gonna do something, then by George, you better do it. Being true to your word is important because you don't want to lose trust in *yourself*. Lying is despicable, and when you can't even trust yourself it's the worst. It goes back to the concept that there's only one of us here

WE TAKE LEAD FROM OUR
DESIRE TO BE FREE.

and we are all one. Where you start and I begin is an illusion. No one benefits more from doing what you say you're going to do than you.

STICK-WITH-IT-NESS

When I started out in the business, there were hundreds of other starstruck kids who had moved to the city with dreams of making it big and seeing their name in lights, many of them smarter and more talented than I was. But I believe my ambition, stick-with-it-ness, and willingness to roll up my sleeves and get to work gave me the edge needed to go the distance. Many people see the glamorous aspects of being in the spotlight, but few realize the commitment to research, rehearsal, discipline, and focus it takes to earn the right to stay in that spotlight. It's been said of the greatest stars that they didn't step on people to reach the top; more accurately, they stepped over people. Many of the people I started out with were their own undoing. Inner demons left unprocessed insidiously sabotaged every opportunity that came along. You know the ones who identify with the problem and not the solution. If you try to offer a solution, they won't hear of it. It becomes very clear that the crank calls are coming from inside the house. Either get out of the house or immediately condemn that property.

FINANCIAL STATUS

I didn't make any real money until my early thirties. Up until then I had been living from hand to mouth working in nightclubs. My first bit of real coinage came when I got an advance on my recording contract. The money was used to produce the album and I used whatever was left over to live on. Most record deals at that time were basically high-interest loans, with the record company getting their investment back from building an awareness and potential record profits later. Luckily, the album did ok, but I don't remember making any direct profits from it. My profits came from building my name brand.

In recent years, the record business has changed drastically, but back then, very few acts with recording deals made their money from record sales. The big money came from touring, and I did my fair share of that, and still do. The album was thought of as an advertisement for the live performance and also branding the name. My brand began to attract endorsement deals with large companies who wanted me to endorse their products. In 1994, I signed a contract to be the first face of M.A.C cosmetics and that's when it all paid off.

I grew up hearing all the stories of the Motown stars who had squandered their fortunes and were left penniless and I was dead set on not becoming another show business statistic by following in their footsteps. Of

course that's easier said than done, having been raised by backwoods people who'd had no real experience with money. The odds are very high that the cycle of poverty will repeat itself. I knew at least to save what I had and not spend it on flashy crap meant to impress other people.

I bought a condo in Manhattan's West Village because I knew it was safe to invest in real estate that wouldn't depreciate and I did some safe mutual funds and money market accounts. For the most part, I wasn't very extravagant at all—I saved my money. Having been in show business for twelve years at that point, I knew it could all come crashing down at any moment. I just kept working and saving. Oh, and paying my taxes, which were a little under a third of what I brought in each year.

I wasn't tempted to try and "bling it out" because I had already experienced "the finer things in life" when I was a teenager living with my sister and brother in-law (who have since divorced). My brother in-law had big dreams and a golden-tongue that allowed him to acquire big-ticket items with little or no capital. He could talk anyone into anything. At just twenty-two, they were driving Mercedeses, Porsches, Rolls-Royces, and Jaguars while living in a multi-million-dollar home in the hills. In reality, the cars and house weren't owned by them, but that didn't matter, they were in possession and it felt real. I lived with them from the time I was fifteen until I was twenty-one. Cash poor, but rich in appearance. It was completely empty and not satisfying. I had no interest in trying to re-create that scene when I hit it big.

I focus on
projects that
get me excited

My wealth would not rely on what other people assumed about me. True wealth is having a healthy mind, body, and spirit. True wealth is having the knowledge to maneuver and navigate the mental obstacles that inhibit your ability to soar.

INTELLECTUAL PROPERTIES

Creatively, I focus on projects that get me excited and feed my desire for beauty, laughter, and love. Financially, I focus on intellectual properties that will bring revenue without me having to physically be there to collect the cash. Musical compositions, published materials, patented concepts and ideas, film royalties, and endorsement deals all generate revenue without having to show up every day to collect. Owning rental properties can generate cash but not without their fair share of headaches created by dealing with tenants.

Ten Things I Learned From Watching Judge Judy

1. **Don't lend money.** Give it if you have it to give, but only under the condition the recipient never ask for it again.

2. Always have a written contract, even with family and friends.

3. **Listen carefully.**

4. Never cosign a loan.

5. **Never open** a joint checking account or get joint credit cards.

6. Don't invite an unemployed love interest to move in just to "play house."

7. **Avoid conflict,** especially physical.

8. Keep records: paper trail, e-mails, texts, phone messages, video.

9. **Do not allow** BB guns anywhere.

10. When in doubt, call the police.

Confession **Halloween**

I've always held a grudge against Halloween. I never go out on Halloween or wear a costume because, besides all the drunk people giving me the creeps, it's amateur night. My resentment stems from the hypocritical concept that it's okay to dress up one day of the year, but not okay any other day of the year. So I've always chosen to protest by dressing up every day except that one. Listen, I know it's ridiculous, but I can't help it.

Confession **Shirttails**

I like to tuck my shirttails into my underwear to keep my shirt flat to my body. Hip-hugger men's underwear works best because the band is much lower than the waistband of my slacks.

Confession **Wearing a Tie**

To keep my tie from moving around, I adhere the tie to my shirt with double-sided tape. I prefer to use toupee tape because it's much stronger than regular double-sided tape. Who needs a bulky tie clip when you've got toupee tape?

Confession **Driving**

I take my shoes off while driving so as not to mark up the heels.

LET'S TURN
THE NIGHT INTO
TOMORROW

THE RUBAMAS

ACKNOWLEDGMENTS

MATHU ANDERSEN

When I met Mathu back in 1990, I had no way of knowing the impact this beautiful Renaissance man would have on my life. I have cherished every moment of these twenty years that we've spent in dressing rooms and soundstages around the world. The lessons I have learned from him have broadened my aesthetic and made me who I am today. I'm crying tears of gratitude as I write this, because it still amazes me how blessed I am to know him. Every photograph, every hairdo, and every makeup look in this book was created by him. He, together with Zaldy, created the images that would propel me into the pop culture lexicon like no other drag queen had done before. His innate ability to deconstruct abstract concepts and magically transform them into art is nothing short of miraculous. He is my idol, my teacher, my friend.

ZALDY

Ninety-five percent of all the clothing you see in this book was designed by Zaldy, the most brilliant visionary I have ever worked with. For the past eighteen years, he has created my most extraordinary ensembles. I've worn many designers, but no one has ever turned me out the way he has. He understands my proportions, and he designs to enhance my frequency. His aesthetic is esoteric and avant-garde, yet his approach is timeless and classic. He knows the craft and he loves it. He's taught me so much about color, texture, and style. I'm proud to call him my friend.

RuPaul skyrocketed to international fame with the release of the CD *Supermodel of the World,* which was followed by roles in several feature films, hosting a TV talk show and a syndicated radio show, many high-profile endorsement deals (including a beauty contract with M·A·C cosmetics), blockbuster success with The RuPaul Doll™, sold-out nightclub appearances worldwide, a bestselling autobiography, and fund-raising millions of dollars for people living with HIV/AIDS. RuPaul is currently the producer and host of the globally popular TV show *RuPaul's Drag Race.*